IMAGES
of America

CEMETERIES OF THE WESTERN SIERRA

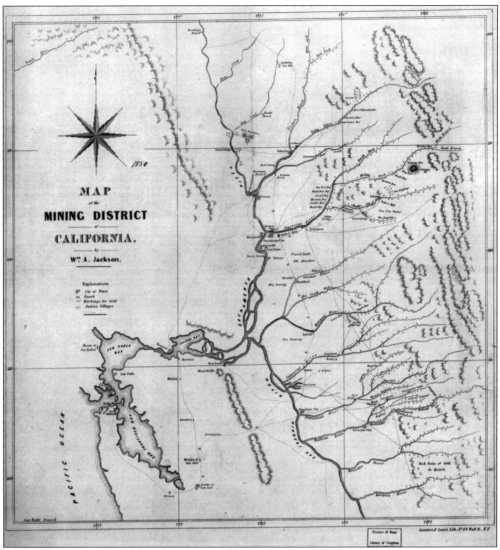

This map depicts the mining districts of California in 1850. Yuba County was formed at statehood in that year. Placer and Nevada Counties were apportioned from Yuba County in 1851, and Sierra County from parts of Yuba County in 1852. (Courtesy of the Yuba County Library, California Room, Public History Archives.)

IMAGES
of America

CEMETERIES OF THE WESTERN SIERRA

Christopher A. Ward

ARCADIA
PUBLISHING

Published by Arcadia Publishing
Charleston, South Carolina

Printed in the United States of America

Library of Congress Control Number: 9781467134965

For all general information, please contact Arcadia Publishing:
Telephone 843-853-2070
Fax 843-853-0044
E-mail sales@arcadiapublishing.com
For customer service and orders:
Toll-Free 1-888-313-2665

Visit us on the Internet at www.arcadiapublishing.com

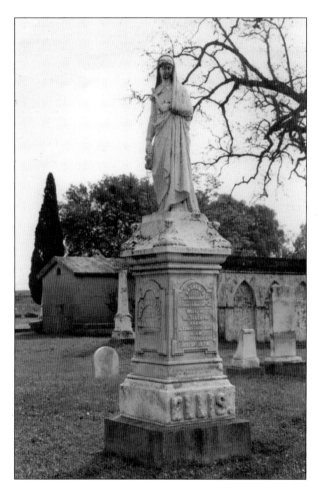

The goddess figure, as personified by the Christian image of Mother Mary, overlooks the Ellis family graves in the historic Marysville City Cemetery. The photograph was taken in 1977. (Courtesy of the Yuba County Library, California Room, Public History Archives.)

CONTENTS

ACKNOWLEDGMENTS

Images in this book appear courtesy of and with many grateful thanks to Searls Historic Research Library (SHRL), California Historical Society (CHS), Nevada County Historical Society (NCHS), Sierra County Historical Societies (SCHS), Colfax Area Historical Society and Archive (CAHSA), Wheatland Cemetery District (WCD), Sierra County Clerk and Recorder, Doris Foley Library for Historical Research (DFLHR), Marysville Cemetery Commission (MCC), Iowa Hill Community Cemetery Inc. (IHCC), Colfax Railroad Museum (CRM), Friends for the Preservation of Yuba County History (FPYCH), Community Memorial Museum of Sutter County (CMMSC), Black Bart's Ornamental Iron, Yuba County Library (YCL), Nevada Cemetery District (NCD), Library of Congress (LOC), Sunset Publishing Corp., Yuba-Roots, Society of California Pioneers (SCP), Grass Valley Museum (GVM), Spenceville Wildlife and Recreation Preserve, Find-A-Grave, *Sacramento Bee*, the *Union*, Arcadia Publishing, and the author's collection (CW).

A special thank-you to Mi Cielo Gem Platte, Kathleen Smith, Amber Guetebier (AG) and family, Kathleen Kershaw, Robin Yonash, Maria Brower, Steve Pauly, the Stevenson family, Jacob Hunter and family, former Humbug Dale Wells, Pat Chesnut, Regina Zurakowski, Leroy Prindle, Victoria Tudor, and California State Parks.

This could not have been done alone, or without the encouragement, insight, and contributions of many. Thank you.

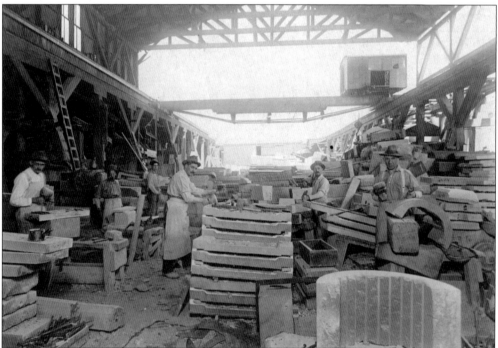

Pictured is a group of stone and grave monument cutters in Placer County, likely Penryn, around 1911. Frequently overlooked, the signature of a stonecutter or company name is often etched along the base of many gravestones. (CAHSA; CHS PIC 2015.1969.)

INTRODUCTION

These monuments mark the historic spots
Where several hundred lie buried. The stream of life flows on but it matters not
To the sleepers here, by the world forgot. The heroes of many a tale unsung,
They lived and died when the west was young.
They played the drama called life – for fortune and fame;
Lost their lives – lost the game. Upon these quiet hills, the long trail past,
These men of restless will, find rest at last.

— C.W. 1954

It is impossible to tell the story of the Sierra cemeteries without telling the story of the people, places, and events that came before them. Many of us respect and venerate our own traditions, but no matter what hill or valley we visit, there are always a people whose roots reach deeper than our own. In attempting to honor the ancestors and elders and visit the pioneers by paying their final resting place a visit, we have traversed some of the most picturesque and mysterious hollows and mountainsides, incredible forests and meadows, and stunning valleys and vistas of the Western Sierra.

When walking in the mountains or in some quiet meadow, and while letting your gaze wander from here to there, it is certain that your eyes have fallen upon a sacred place of the interred. The mountains and the meadows of the Sierra Nevada are dotted with traces of the lives lived and lives gone but not forgotten.

The intimate knowledge of the land that the Native American peoples of the Western Sierra gathered over centuries was not always known to the early pioneers, and many paid for this ignorance with their lives. The now infamous madness-inducing discovery of gold along the gravel-laden and boulder-strewn banks of the American River by James Marshall in January 1848 changed Northern California forever. A few months later, Jonas Spect, with the help of an indigenous guide, would also encounter the golden metal along the edges of the lower Yuba River. That was in the late spring of 1849, and everything going forward, every organism, every stone, would be altered by these discoveries. By early 1850, the Native American village Wi'lili', near the Yuba gold discovery site, had been completely razed; in its place, a seething mass of at least 600 men (and nine women) were hastily transforming every miner's inch of their surroundings. The banks of every river and the tops of every hill soon were alive with the clamber of new townships with colorful names like Timbuctoo or Hell-Out-for-High-Noon City.

The quest for gold in the Sierra ignited a dramatic population increase in the northern half of California, particularly throughout the Sierra Nevada, as immigrants poured into the territory seeking gold or the opportunities associated with it. By 1849, roughly 90,000 people had come to California, and by 1855, almost 300,000 had arrived from around the United States and abroad. This relentless human river continued to flood California well into the early 20th century. It was during this era, 1848–1920, that virtually all of our now historic cemeteries were established and began to be populated.

Among the surviving landmarks that symbolize, or indeed epitomize, the rigors of early pioneer existence in the Western Sierra Nevada and foothills are their graves. The remote historic cemeteries and lone burial sites, ever-present companions of the myriad Gold Rush–era camps, villages, and townships, are now mostly relegated to memory.

The number of marked and unmarked graves and cemeteries throughout the Western Sierra Nevada would provide enough material for numerous volumes of this size. It is not the author's intention to document every one, but rather to give a snapshot of what lies beyond the meadow's edge and a glimpse at the assortment of poignant stories that may lie hidden beneath the pine-needle bed of the forest. By looking at history through the lens of the cemetery, we, perhaps with a touch of irony, restore life to the stories of our native inhabitants, towns, cities, and mining camps. In so doing, we begin to learn the names and the tales of California's citizens: the miners and builders, the storekeepers and hotel proprietors, the newspapermen and politicians.

The plight of the remaining monuments in many of the historic cemeteries throughout the Sierra is dire. Vandalism and desecration, tree-fall, overgrown nonnative vegetation, erosion, exposure, failed restoration attempts, acid rain, and simple neglect are all contributing to the loss of one of our most valuable historical assets. This book is an attempt to honor the principles of preservation and awareness and recognize the impacts, made clear not only by visits to the cemeteries themselves but by speaking to the people involved with them. Without the seemingly limitless efforts of volunteers, California's historic Gold Rush–linked cemeteries would be in an outright crisis of extinction. Combined with the hard work of often modestly funded cemetery districts, commissions, and a few private funerary services, our Gold Rush–era cemeteries endure as silent lessons in history.

This is dedicated to our ancestors.

One

THE LAND OF BENDING WATER

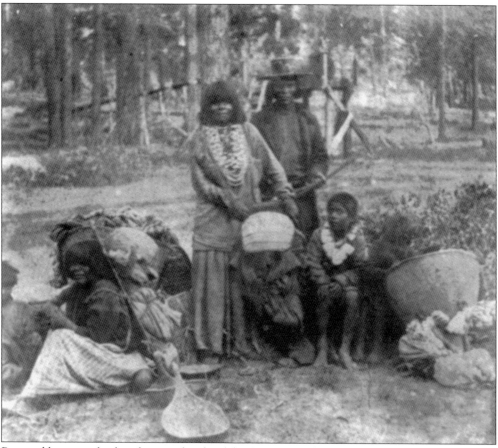

Pictured here is a displaced native family of the Sierra Nevada in 1866. The constant disruption of family life grew to be a daily occurrence among the native peoples of the Gold Rush region. The ancestral burial grounds of local indigenous family groups dot the landscapes of every corner of gold region. Displacement, disease, and a prevailing social ignorance acted against regional indigenous groups and their cultural practices. (SHRL.)

This photograph, taken around 1907, shows an Indian cemetery on a historic ranch outside of the bustling foothill town of Grass Valley. A local newspaper reported in 1907 of the "Indian Cry" ceremony being performed here. The article states that "Old Kapi" was "the last chief to be burned according to ritual," and that some 30 years earlier, "Nellie" was "the first to be buried in a coffin." That was in 1877. (SHRL)

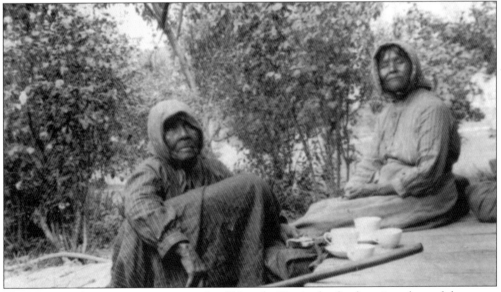

The private indigenous cemetery outside of Nevada City is the final resting place of these two Nevada City–area native women known locally as Betsy (left) and Josie, pictured around 1910. This venerated burial ground is under the jurisdiction of the Nevada Cemetery District and is only open by appointment. (SHRL.)

Two

NEVADA COUNTY AND SIERRA COUNTY

This illustration by
Thomas Ayres is
titled "The Departure,
A Miners' Burial."
The image, with its
accompanying poem,
appeared in *Hutchings'
California Magazine
1860*. The magazine
was the creation of
miner, traveler, and
writer J.M. Hutchings.
The poem reads: "In
a dark, shady glade on
the side of a hill, that
was then draped by
clouds in a mantle of
rain. In a deep grave
they laid him, all
solemn and still and
the winds murmured
o'er him a mournful
refrain." (CW.)

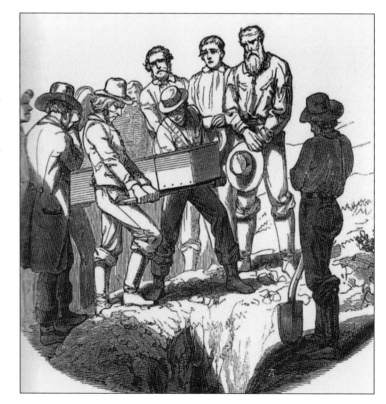

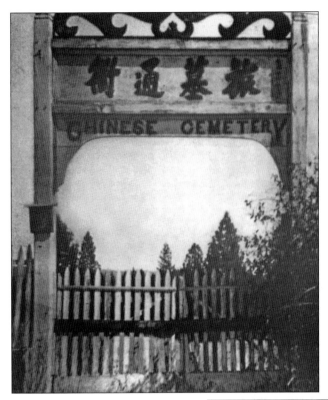

This is the original gate to the Chinese cemetery in Nevada City, photographed sometime before the 1930s. The succeeding reconstructions have done well to adhere to the original design but betray a few significant differences. The large horizontal characters translate as: "Passageway for the graves of those who are away from home," and the small vertical characters on the right represent the date August 1891. On the inside of the gate, an additional inscription reads, "Villa screened by clouds." The latter two inscriptions are not present on the current cemetery gate. Note the collection box mounted on the left. (SHRL.)

This photograph of the gate, taken by Miles Coughlin in 1935 and which appeared in the *Independent* in 1979, illustrates a fine reconstruction, though missing some original elements. The cemetery appears more densely wooded, in contrast to the earlier photograph, indicating that it had fallen into disrepair and was most likely no longer being used by the few remaining members of the Chinese community. (The *Independent*.)

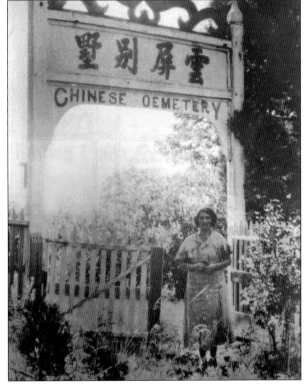

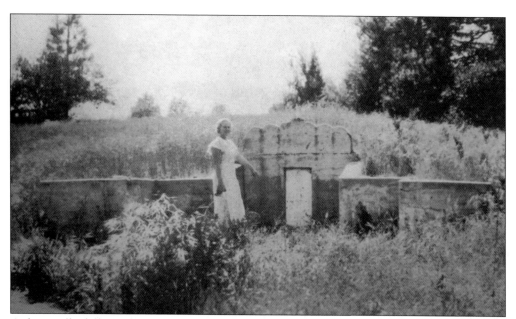

A drastically different background and brushy foreground are seen in this 1930s photograph of the spirit shrine. The shrine, built in a crescent shape, mimics similar Chinese cemeteries in San Francisco and China. The scalloped marble capital is reminiscent of a cloud, and the overall form of the shrine is representative of heaven and earth. The marble centerpiece, sorely damaged by shotgun fire, bears the inscriptions "Tablet where one offers sacrificial food and pay's one's respects," the Chinese characters representing the date 1891, and "Rebuilt on the propitious day in the first moon of autumn." (SHRL.)

Pictured is the funeral notice of Sam Sing, interred in the Nevada City Chinese cemetery in 1874. Funeral notices were often simple handbills circulated by post or other means. Frequently, the printer would distribute the notice, pinning them on local bulletin boards, listing them in directories, and placing them in local businesses to get the word out. (DFLHR.)

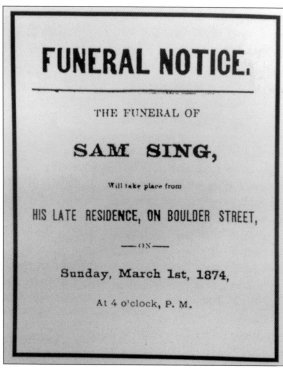

FUNERAL NOTICE.

THE FUNERAL OF

SAM SING,

Will take place from

HIS LATE RESIDENCE, ON BOULDER STREET,

—ON—

Sunday, March 1st, 1874,

At 4 o'clock, P. M.

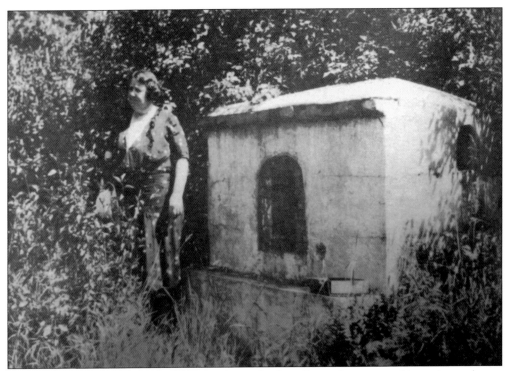

Pictured here in 1935 is Emily F. Steger alongside the offering burner, or *chitan*, situated near the spirit shrine. The funerary kiln-like structure was used to burn offerings of tobacco, money, incense, and other articles particular to the deceased. The burner may also have been used to burnish the excavated osteological remains of the deceased prior to shipment, usually back to one of two primary cemeteries in China for ancestral repatriation. (The *Independent*.)

Today, the spirit shrine (right) and the offering burner are hidden by tall pines and gently obscured by manzanita brush and invasive berry vines. The spirit shrine has suffered vandalism, gunshots, and neglect, despite well-meant efforts of land owners and concerned individuals. (CW.)

This is a depiction of the town of You Bet as it appeared in Thompson & West's 1880 *History of Nevada County*. Named You Bet by Lazarus Beard, the mining hamlet housed several buildings and residences, including a schoolhouse and an Odd Fellows Hall, which was relocated from the town of Red Dog. The original townsite sat atop a hill now completely washed away by the endeavors of the gold-fevered inhabitants. Almost nothing is left of the thriving Gold Rush town except the cemetery, established in 1859. You Bet grew from a small mining camp in 1857 to a thriving village by 1860. Red Dog moved entirely to You Bet in 1869 after the great fire in April of that year. (Doris Foley Library for Historical Research.)

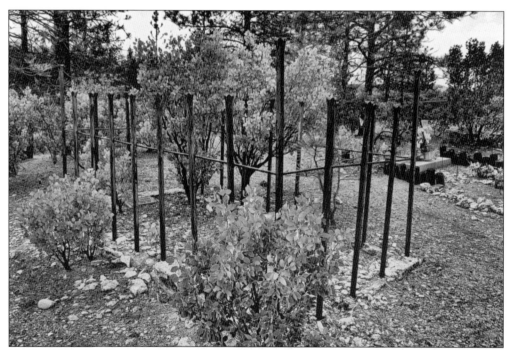

You Bet Cemetery has a great many miners buried within the hallowed hill saved from the water cannon's blast. At the grave of this miner, the protective perimeter fencing is made from pneumatic drill bits used in hard-rock and drift-tunnel mining. (CW.)

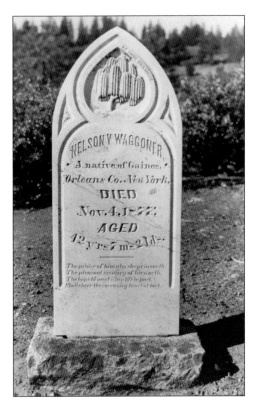

Pictured here in 1960 is the grave of Nelson V. Waggoner (1835–1877). A native of New York, Waggoner came like so many others in search of California gold. He was a member of the Odd Fellows and was shot dead in Auburn, California, while prospecting at Gold Bar along the American River in Placer County. (SHRL, Lyle White Collection.)

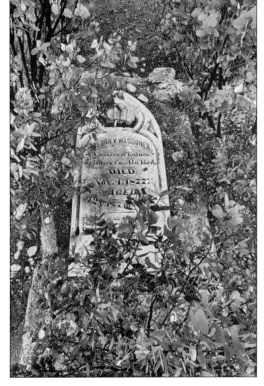

This is a recent photograph of Waggoner's grave. Waggoner died from a gunshot wound to the chest courtesy of Paschal Varnum, with whom he owned a mining claim. Waggoner's body was transported from Gold Bar to Auburn, then took a long wagon ride out of the river canyon to You Bet accompanied by an honor guard dispatched from the local order of Odd Fellows, Grass Valley Lodge No. 12. His epitaph reads, "The praise of him who sleeps in earth, / The pleasant memory of his worth, / The hope to meet when life is past, / Shall cheer the sorrowing heart at last." (CW.)

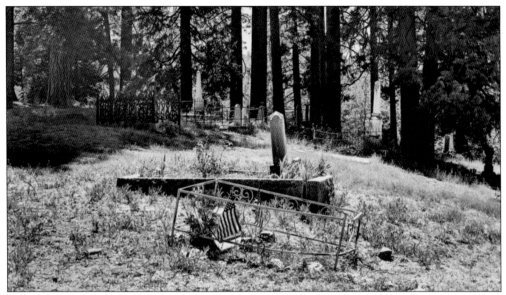

Here is the grave of miner and Mason James Charles Young, who died on January 4, 1872. It was erected by Forest Lodge No. 66 of the Free and Accepted Masons. The Treasure Town (or Alleghany) Cemetery was established around 1854 and offers impressive views of the Kanaka Creek Canyon and Middle Yuba River gorge below. Many graves here still display fine examples of artisan cast-iron perimeter fencing. (CW.)

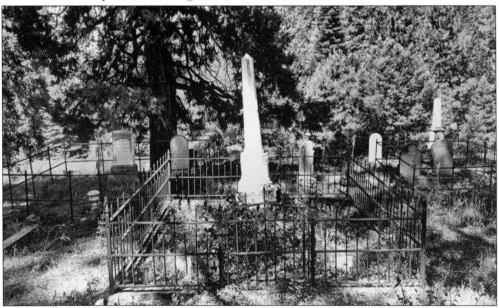

Visitors pass over the remains of the Chinese cemetery en route through Alleghany Cemetery's main entrance. Shown here is the grave of Emma and John Bradbury, who died in 1876 and 1878, respectively, lifelong members of the Masons and Daughters of Rebecca and parents of Thomas Bradbury, who would be associated with the founding of the Sixteen-To-One Mine in 1896. Emma's gravestone depicts three chain links and the letters PNG, signifying past noble grand—the highest office in the Daughters of Rebekah. Several members of the Bradbury family are interred here, as are numerous miners' families. (CW.)

This c. 1920s photograph of Alleghany was printed on a 1950s-era postcard titled "Alleghany, Lima County Gold Country, California." The view includes a church at center right. A Protestant church originally shared the same parcel with the cemetery. (CW.)

The grave of Harriet Patton, a pillar obelisk of uniquely striated granite, offers a view of Kanaka Creek ravine. The name Kanaka is said to be of Hawaiian origin, so named by a small group of miners from the Sandwich Islands (Hawaii). Alleghany is said to be a slight miner-given spelling of the native Delaware word for the river in Pennsylvania. (CW.)

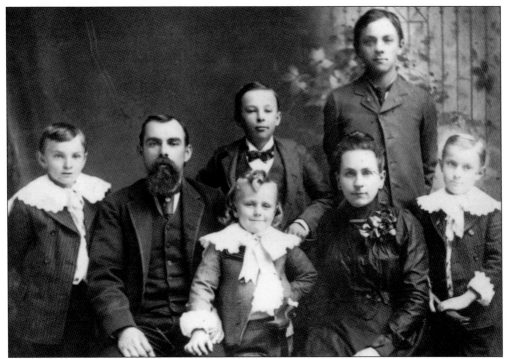

Pictured here in the 1880s is the Kneebone family, with Andrew Kneebone at center. The Thompson, Kneebone, and Cole families were mostly farmers and ranchers. Andrew Kneebone was a well-known teamster whose family is interwoven with regional history. Patriarchs Joseph Kneebone Sr. and Jr. would both die tragically at different times, outside Spenceville to the west, victims of unsolved murders. The Kneebone-Thompson-Cole Cemetery dates to 1853 with the burial of Capt. William Thompson. (SHRL.)

The Kneebone-Thompson-Cole Cemetery is pictured here during an unusual flood in 1997. This small cemetery of only 12 known interments is a historical jewel, nestled above the left bank of the Yuba River with the South Yuba River State Park nearby. The park's covered bridge at Bridgeport (California Historical Landmark No. 390) is famous in many ways and has played a significant role in the development of the region. (SHRL.)

This glass-plate photograph features a young Victoria Kneebone (1862–1930). Victoria was born at Bridgeport. She married Andrew Kneebone in Marysville in 1887 and lived at Andrew's family's Spenceville Ranch. She was 68 when she died at the Spenceville Ranch, and is interred in Bridgeport. (SHRL.)

Included in this photograph of the Kneebone-Thompson-Cole cemetery from around 1960 is the grave of Capt. William Thompson. Prior to his adventures that would lead him to the Yuba, Thompson was a ship captain who infamously abandoned his charge in the San Francisco Bay area and made his way to the goldfields. His daughter Fannie is interred beside him; she died at the age of six, in 1856. The latest person to be buried here was Lucile C. Kneebone, in 2011, at the age of 93. The cemetery is nicely maintained and looked after by descendants and park volunteers. (DFLHR.)

Pine Grove Cemetery, established around 1851, is named in honor of Mary Ann Groves, wife of the village undertaker and local businessman William C. Groves. Over time, additional cemetery lands were allocated for numerous benefactors: the Woodmen of the World, Knights of Pythias, Order of the Eastern Star, veterans, and prominent individuals among the community. The local Masonic lodge, to this day, assists in the care of sections of the cemetery with the aid of other local organizations like the Nevada Cemetery District and the dedicated volunteer efforts of the Heirloom Rose Association of Nevada County. (CW.)

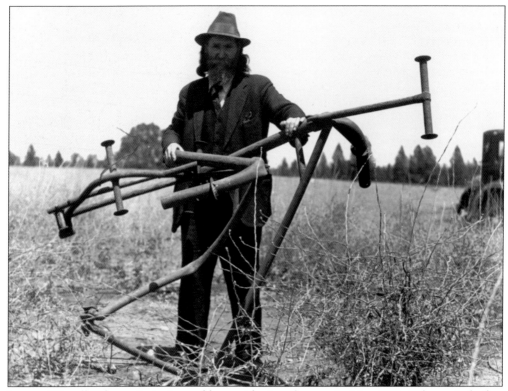

Lyman Wiswell Gilmore Jr. is pictured here with aircraft parts. In May 1902, Gilmore Jr. built a 32-foot aircraft that was reported to have successfully flown through the air at a rate of 43 miles per hour under power of his custom-built steam engine. As the story goes, only a handful of witnesses were present at this inaugural flight on Gilmore Fields. Many who were not there had trouble believing his claims. A hangar fire destroyed what he termed his proof. Gilmore consistently claimed that his flight took place months before the Wright brothers' flight at Kitty Hawk and spent the rest of his life trying to convince people of what he knew as fact. (SHRL.)

The humble grave of Lyman Gilmore is located in Pine Grove Cemetery, just outside of downtown Nevada City. The gravestone reads, "Inventor Lyman Gilmore" and resides next to his partner, mechanic, and brother Charles. Lyman Gilmore was born on June 11, 1876, in Washington state; he died and was buried in Nevada City on February 18, 1951. Lyman Gilmore Middle School, his namesake, now stands in the location of the airfield. No trace of the airfield exists today except an open field on the western edge of the school. (CW.)

Pictured here are Daniel Marsh (left) and Martin Luther Marsh, two young entrepreneurs of Nevada County. The Marsh family arrived in Nevada County in 1850 and quickly saw opportunity in the home-building business. The Pioneer Saw-Mill, a partnership of A.B. Gregory and the Marsh brothers, once encompassed the areas along Little Deer Creek, Nevada City, near the present-day beautifully wooded Pioneer Park. This photograph is said to have been taken on Christmas Eve 1862. (SHRL.)

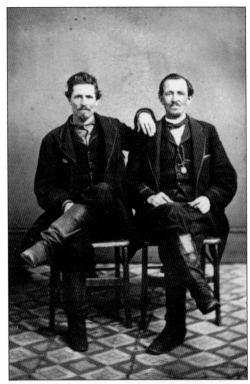

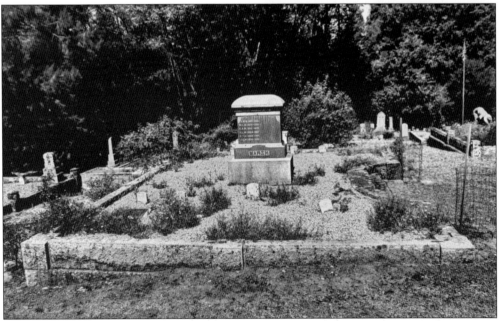

The Marsh family grave monument resides within the Masonic section of the Pine Grove Cemetery. Nevada, as the town was originally known, was given the moniker "Queen City of the Northern Mines." The monument, inscribed with multiple generations of names, is a massive blue granite block with grey granite capital and pedestal. The plot itself is aromatically adorned with heirloom varieties of lavender, rosemary, and lily. (CW.)

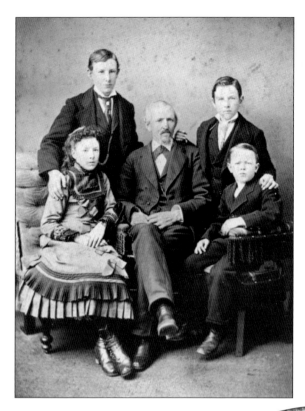

Pictured at left around 1875 is a mature Martin Luther Marsh (center) with his family in Nevada City. The photograph was taken after the death of his beloved wife, Emma Ann (Ward) Marsh. Those pictured are, from left to right, daughter Maria Jane and sons Sherman, Charles, and John. (NCHS.)

This is the emblem of the Ancient Order of the Forester (AOF), of which the Marsh brothers were members. The AOF is one of the oldest friendly societies, originating in England in 1790. In the late 19th century, Forestry spread throughout the world, and with the insatiable lust for timber that the Gold Rush brought, it came to California. In 1892, the order was opened to women. The motto is "Unity, Benevolence, and Concord" (sometimes given in Latin as *Unitas, Benevolentia, Concordia*), here etched around the base of the emblem. (CW.)

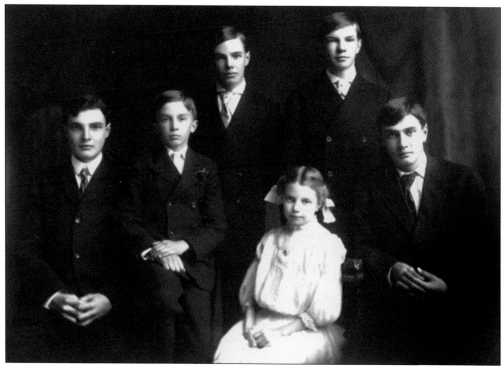

This handsome pre-1900 photograph, likely taken in a formal Nevada City studio setting, shows the six children of Niles and Mary Ann Niles Searls: Niles, Carrol, Robert, Henry, Fred, and Helen. A pioneer-era Nevada City family, the Searlses have long been valued and influential community members. (SHRL.)

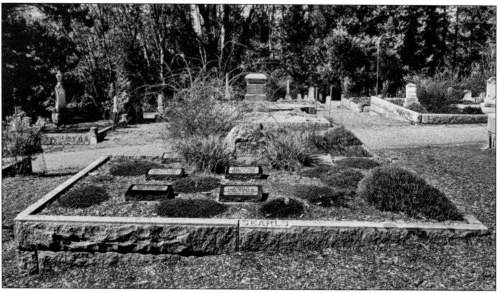

The Searls family plot, seen here in 2014, is situated just inside the Masonic section of the Pine Grove Cemetery. The family plot and Masonic section of the cemetery are very nicely maintained by family members and dedicated volunteers. The verdant gravesite is a striking and comparatively rare positive example of the meeting of time and respect. (CW.)

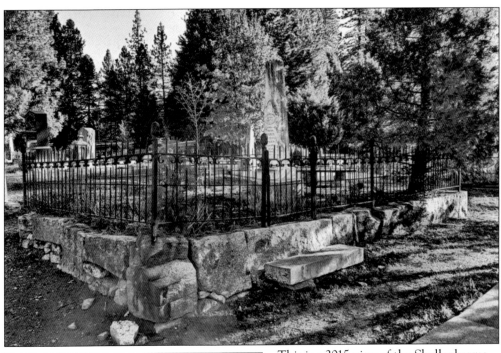

This is a 2015 view of the Shallenberger family gravesite memorializing Aaron (1826–1877), his wife, Sarah (1836–1886), and daughter Laura Ann (died 1864, at one year old). The beautiful grave plot holds the family of the paternal cousin of Moses Shallenberger of the Stevens-Townsend-Murphy Party of 1844, the first pioneer party to crest the Sierra Nevada by wagon. Aaron Shallenberger, one of seven children of Jacob and Catherine Elizabeth Miller, would follow in the intrepid footsteps of his cousin, lured by news of gold along the Yuba River. Aaron arrived in Nevada City in the early 1850s and garnered at least two productive and lucrative claims. He eventually married Sarah Ann Kitson and had five children. (CW.)

Pictured here is the funeral notice for Sarah Shallenberger. Funeral notices were a common publication. They appeared as inserts in local newspapers and periodicals and were posted in public areas. Unfortunately, this funeral notice is spelled incorrectly, a printer's mistake. (SHRL.)

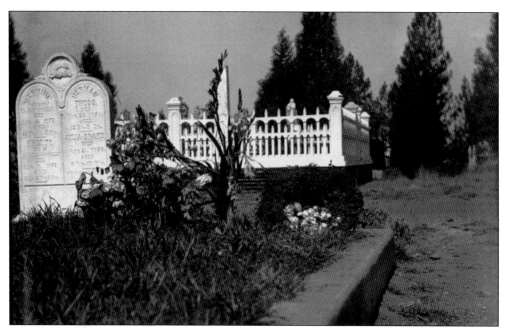

The Harryhousen, Brand, and Thoss gravesite is shown above in a rare glass-plate photograph from around 1897. Note the garden-like setting, grass, and bouquets of lily of the valley, a popular funerary flower. Missing in the 2014 photograph below are the grass, the flowers, and the ornate perimeter fencing. (SHRL.)

This is the Harryhousen, Brand, and Thoss gravesite as it looked in 2014. Originally, more utilitarian fences were used to prevent wandering livestock from trampling the gravesites of loved ones, but these barriers evolved during the Victorian era into impressive works of craftsmanship. The most dramatic difference is the background; as with many historic sites, the trees, as a rule, were once much fewer in number. (CW.)

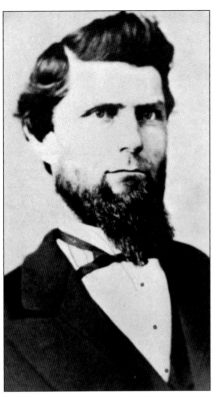

This is a portrait of Loring Wallace Williams (1832–1874). The Williams-Humes family plot in the Pine Grove Cemetery holds the remains and memories of Loring and his family. Loring, born in Illinois in 1832, was 17 when his parents, John and Abigail Kellogg, and siblings immigrated to California. By the age of 18 in 1850, he accompanied his father to Nevada County and there acquired a claim at Gold Flat. (Hermann Collection, 1966.)

This is an 1867 advertisement for W.C Groves, undertaker. L.W. Williams was educated as a lawyer, taking a partnership in 1864 while serving as undersheriff of Nevada County, and was appointed deputy district attorney that same year. As documented in county marriage records, Loring Wallace and Cornelia "Caroline" Elizabeth Humes, also of Illinois, were married in Nevada City in 1855 and had four sons during their time together on Prospect Hill. At one time known as the strongest man in town, Loring eventually succumbed to a longtime illness on February 10, 1874. (CWARC.)

WILLIAM C. GROVE,

UNDERTAKER,

BROAD STREET, NEVADA CITY,

A SUPPLY OF PLAIN, WALNUT, MAHOGANY AND ROSEWOOD COFFINS

always on hand, and furnished at short notice

☞ Interments in all parts of the County promptly attended to. ☜

TERMS REASONABLE.

ALSO—PROPRIETOR OF THE

PINE GROVE CEMETERY,

Where LOTS of any size desired may be obtained at a moderate price.

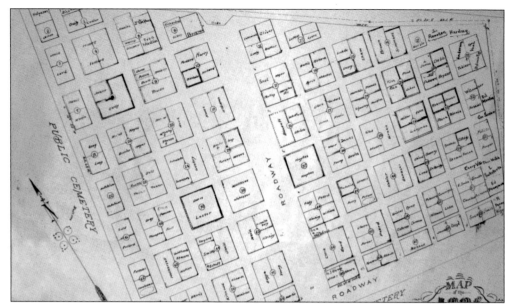

Shown here is the Nevada City chapter of the Independent Order of Odd Fellows (IOOF) plot map from around 1902. The Nevada City IOOF has a rich 162-plus-year history, a legacy that parallels the growth of Nevada City from a rough mining camp to one of the most significant towns in 19th- and early-20th-century California. Aaron Augustus Sargent (buried in the Nevada City Pioneer Cemetery) was selected as the lodge's first noble grand when the charter was issued to form a Nevada City Lodge. Named after the Native American village that once encompassed the vicinity of Nevada City, Oustomah Lodge No. 16 was first established in 1853. (NCD.)

This is the Williams-Humes family plot as it looks in 2015. Time and the ravages of negligence have severely damaged the surviving grave monuments, so much so that Caroline Williams's partially broken (though mended) gravestone is the only one left standing. Cornelia "Caroline" Elizabeth Williams died nine years after her husband, Loring, in 1883. Her gravestone, carved from white marble and adorned by a single Gothic dove with olive branch, faintly bears the engraved sentiment "At Rest." (CW.)

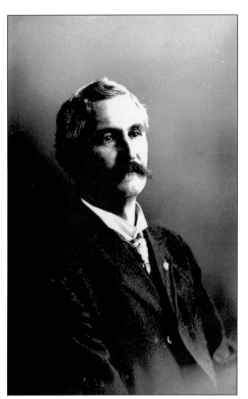

William Fellows Englebright (1855–1915) was a US representative from California from 1906 to 1911 and father of three sons, Harry, William, and Alfred. W.F. Englebright was born in New Bedford, Massachusetts, and moved with his parents to Vallejo, California, and then to the Sierra when he was still young. (SHRL.)

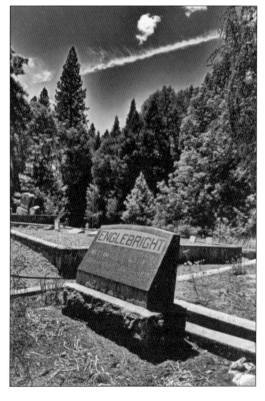

The grave of W.F. Englebright is seen here in 2014. He attended private and public schools, eventually entering into naval yard services at Mare Island, near Vallejo. As a joiner's apprentice, Englebright eventually completed his studies in engineering and would later establish himself in Nevada City during the 1860s as a mining engineer and began working with the Excelsior Water & Mining Co. (CW.)

This is an elaborate Masonic emblem seen in the Elm Ridge Cemetery, with intricately engraved symbolic elements, including the letter G for geometry (also used for God), and a square and compass, which together represent the interaction between mind and matter, referring to a progression from the material to the intellectual to the spiritual. (CW.)

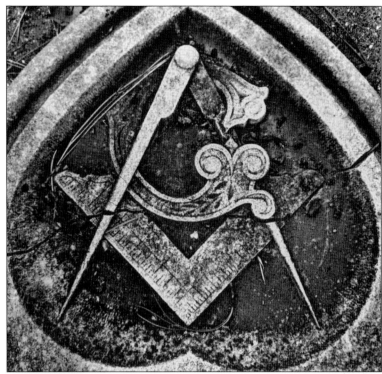

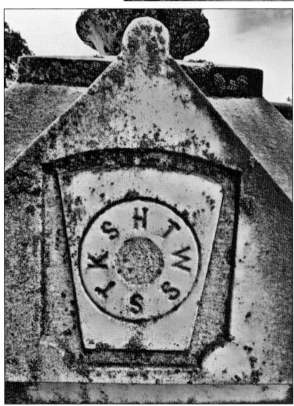

Shown here is the Masonic mark, a symbolic keystone-shaped funerary engraving. The symbol denotes the burial of an ancient grand master and York Rite royal arch Mason. The letters HTWSSTKS signify "Hiram the Widow's Son Sent to King Solomon." W.F. Englebright had numerous fraternal affiliations, including Lodge No. 518 of the Benevolent and Protective Order of Elks, the Knights of Pythias, the Independent Order of Odd Fellows, Knight Templar Masons, and the Order of the Mystic Shrine. He was involved, among many other pursuits, with several land disputes with indigenous populations over water rights and mining claim validity. He died in Oakland, California, on February 10, 1915. (CW.)

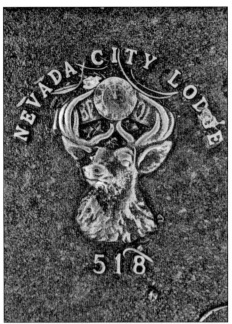

The Benevolent Order of the Elks, whose emblem is pictured here, originated in 1868 as an offshoot of a popular drinking club, the Jolly Corks, and now enjoys over a million and a half members. Elks are active in public service and the caring of fellow Elks. The hands on the clock, used in the symbolism of the order, are perpetually frozen at 11:00, a sacred time to every Elk. (CW.)

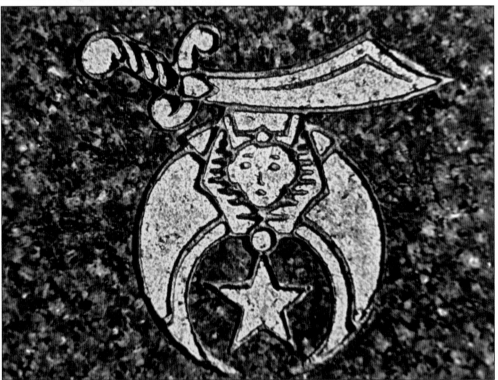

The emblem of the Ancient Arabic Order of Nobles of the Mystic Shrine, widely known as the Shriners, was founded in 1872 by Freemasons W. Fleming and W.J. Florence. It was originally conceived as an elite order—open only to 32nd-degree master Masons and Knights Templar. The order has embraced, with a degree of parody, many icons and symbols of Islam, to the understandable dismay and frustration of many followers of the religion. (CW.)

Harry Lane Englebright (1884–1943) was a political figure like his father before him. He served in the House of Representatives as the minority whip for over 10 years (1933–1943). Englebright attended the University of California, Berkeley and became a mining engineer before entering politics. (DFLHR.)

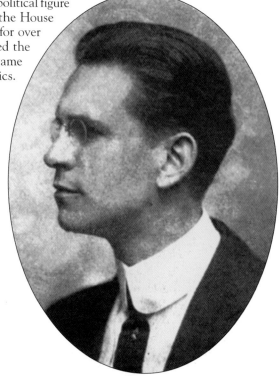

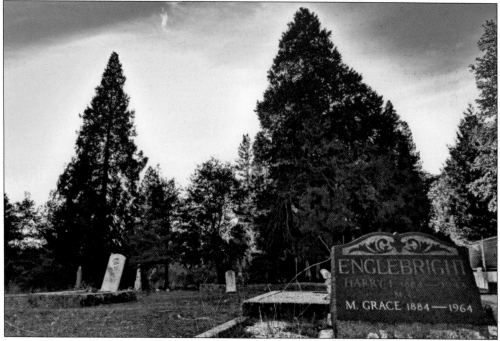

This is the grave of Harry Englebright as it appeared in 2014. Englebright died in office in Bethesda, Maryland, and his remains were transported by honor guard to Pine Grove Cemetery for funeral and burial. Englebright Lake and Dam in western Nevada County are named for him. (CW.)

Pictured here is the Brooklyn Lodge No. 46 Odd Fellows fraternal plot as it appeared in 1969. The fraternal plot was originally located in the historic Red Dog Cemetery, a few miles east, but the burial remains and monuments were moved around 1900 to the Pine Grove Cemetery in Nevada City. The plot has exchanged the Victorian garden-like setting established by past generations for more of a managed drought-tolerant look. The combined efforts of the county cemetery district, local mortuaries, fraternal groups, and devoted volunteer efforts have helped maintain this very special link to the region's history. (SHRL, Lyle White Collection.)

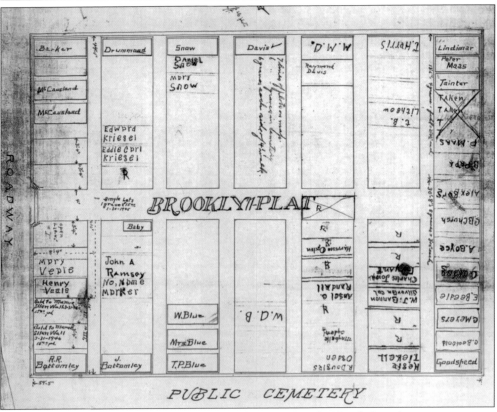

This plat of the Brooklyn Cemetery plot from about 1945 reads, "Single lots, 1 person graves are $15.00." The modern-day equivalent starts at around $1,700. Brooklyn Lodge No. 46 was instituted on October 13, 1855, and eventually consolidated with Oustomah Lodge No. 16 on July 6, 1904. Brooklyn was the original name of Red Dog. (DFLHR.)

The Preston family plot is pictured here in 1887, with elaborate floral adornments likely left from the funeral of Maggie H. Preston, wife of E.M. Preston. From about 1850 until the Great Depression, many of the cemeteries of the Sierra Nevada region enjoyed a more prominent role in the communities they represented. (SHRL.)

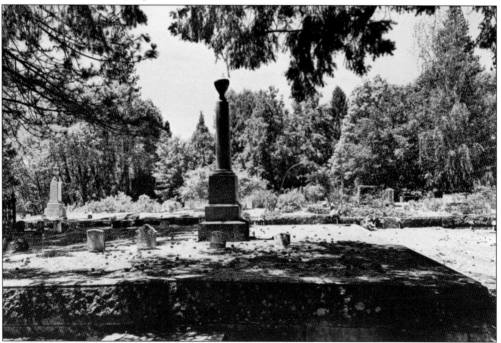

Pictured here is the Preston plot as it appears today. Heritage varieties of rose, lily, and aromatic perennial herbs and flowers were much more common graveside than is typically seen in these sanctuaries today. Historically-minded civic groups like the Heritage Rose Association of Nevada County have in recent years revived and transplanted over 120 varieties of heirloom roses in Pine Grove, restoring a historically accurate garden-like setting to the Masonic section of the cemetery. (CW.)

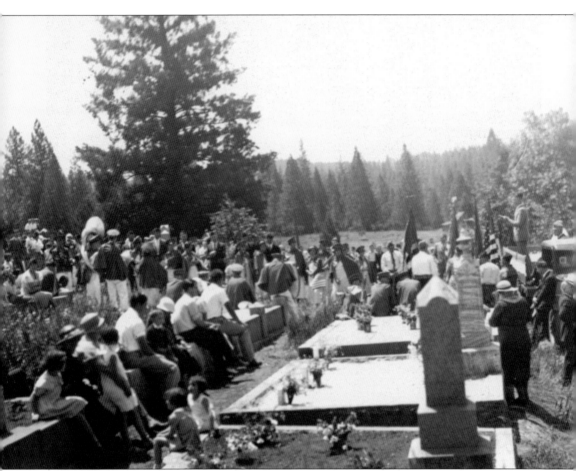

Pictured here is a southerly view of the Pine Grove Cemetery with a large gathering of local well-wishers, including an entire brass band, in the Masonic section for a celebration on Memorial Day 1934. Once a much more popular happening in the region, a procession or parade gathered for Memorial Day could start near downtown and pick up onlookers and locals along the route to the cemetery for festive remembrances. (SHRL.)

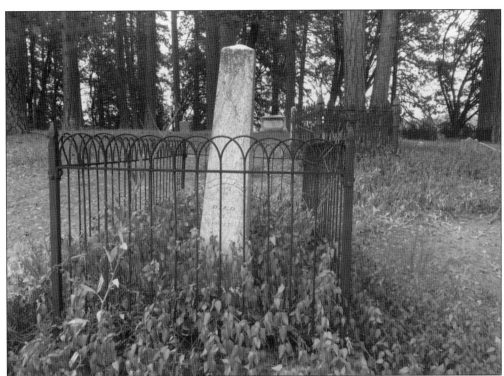

Pictured here is the grave of Alphonse Sutter in the Nevada City Pioneer Cemetery, established in 1850. In 1851, a church was built on the hill, which housed the first village cemetery. Within a year, the church was moved to its current location on Broad Street. Since then, the cemetery has remained undeveloped. Its only neighbor atop Broad Street is the adjoining St. Canice Catholic Cemetery. Just over 100 years after his death, in 1964, Sutter's remains were curiously excavated from their resting place and reinterred beside his father, in Pioneer Grove near Old Town Sacramento, leaving the grave monument in Nevada City intact. (SHRL.)

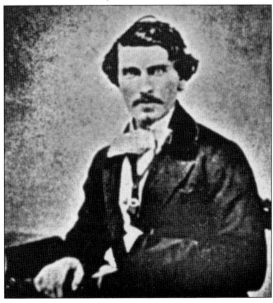

This is a rare photograph taken around 1860 of a seemingly healthy William Alphonse Sutter (1832–1863), the youngest son of the infamous Johann Sutter. "The son of the great General Sutter, William Alphonse, Fell Dead! In the middle of upper Broad Street," the *Nevada Herald* exclaimed in August 1863. Sutter died of prolonged complications from a tropical disease he contracted while captaining a military expedition in Nicaragua in the mid-1850s. (DFLHR.)

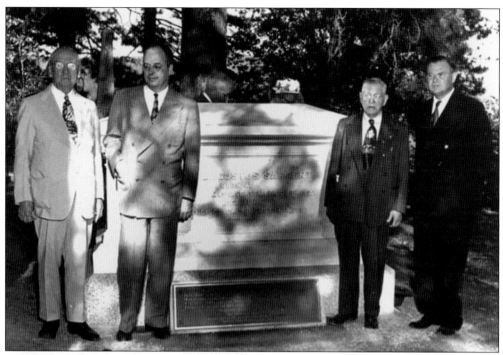

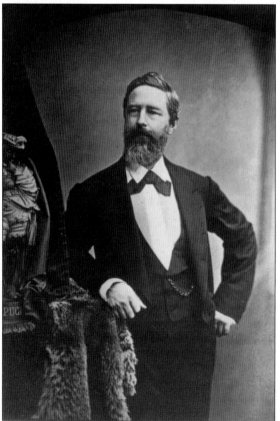

Shown here is the Sargent Memorial during its 1949 rededication. A.A. Sargent is an unusual, though not uncommon, burial in the Nevada City Pioneer Cemetery (also listed as the Protestant Cemetery on historical maps). The sarcophagus-style memorial once marked the grave of the renowned California pioneer Aaron Augustus Sargent (1827–1887) in the Laurel Hill Cemetery of San Francisco. His remains were disinterred, and the memorial was moved by the Native Sons of the Golden West to Nevada City in 1940. His ashes were sprinkled over the land that had been his Quaker Hill–area mining claims. (SHRL.)

This portrait of A.A. Sargent was made in 1874. The act of his burial repatriation was likely influenced by the fact that the Laurel Hill Cemetery, among many of San Francisco's cemeteries, was being relocated and redeveloped throughout the 1920s–1940s. In some cases, the land was appropriated much earlier, from the late 1870s through 1880s. (SHRL.)

This is an early portrait of what may be Nevada City's first grave monument carver, T.F. Dingley. Dingley had a shop on lower Broad Street near the National Hotel, which is still in operation. He would later leave monument carving for investment in mining with his son E.F. Dingley, making a rare successful transition. (SHRL.)

This is an advertisement for Dingley & Folsom Marble Works from around 1855. Before having a local undertaker or monument carver, formal gravestones would have to ordered from out-of-town sources. This meant sending away by letter or mail order to carvers in Penryn, Marysville, Sacramento, Chico, San Jose, San Francisco, or out-of-state (post-railroad) for a headstone. (DFLHR.)

manlike manner. GUNS re-bored and warranted to shoot well. PISTOLS cleaned and mended.

Z. P. DAVIS.

DINGLEY & FOLSOM,
GRAVE STONE CUTTERS

Have constantly on hand an assortment of

GRAVE STONES, MONUMENTS, TABLE TOPS, ETC.

AT THE FOOT of BROAD AND MAIN STS.,
NEVADA.

UNITED STATES BAKERY.

JULIUS DRYFUSS.

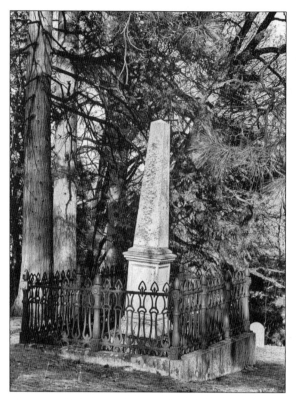

This is the grave of Henry Meredith (1826–1860). Meredith was born in Hanover, Pennsylvania, in 1826. He arrived in Nevada County early in the 1850s ready to practice law. Before Nevada statehood, he joined the rush to the Comstock strikes outside Virginia City. He there entered into a partnership with one William Morris Stewart, the "Silver Senator," and became a first captain in the Nevada Rifles, a volunteer militia force. (CW.)

Shown here is a late 1850s portrait of Henry Meredith. Meredith was involved in a "punitive expedition" and conflict with a group of Paiute Native Americans at Pyramid Lake that left him shot and scalped. "No, leave me here, I might put you in peril," were his last words when offered assistance on the field of battle. His body was returned to Nevada City for burial by the Rifles. He was 34 years old. (SHRL.)

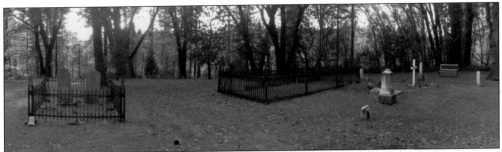

Here is a 2014 view of the Cherokee Cemetery. The town of Cherokee was named for a small group of Cherokee Native Americans who were said to have settled and prospected there in early 1850. This Gold Rush–era ghost settlement is also known as Tyler or Patterson. By 1862, the Grizzly Ditch was completed, and the hydraulic-mining method flourished, bringing over 400 miners to the vicinity. By 1853, the cemetery had been established. The years 1856 through 1865 were the most prosperous era of the settlement. (CW.)

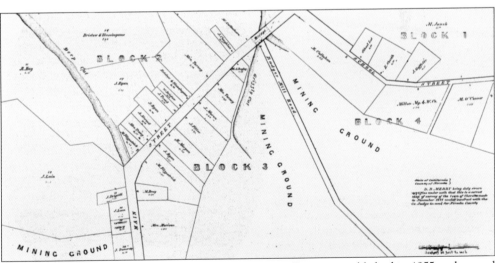

This is an 1874 map of the town of Cherokee. A post office was established in 1855 and named Patterson, but letters continued to be addressed to Cherokee. Eugene Turney built the town's first public hall in 1861, and by 1872 a larger school, to replace the smaller, with a connected library, was in use. (Nevada County Recorder.)

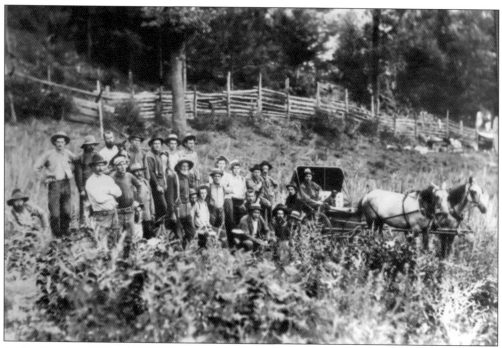

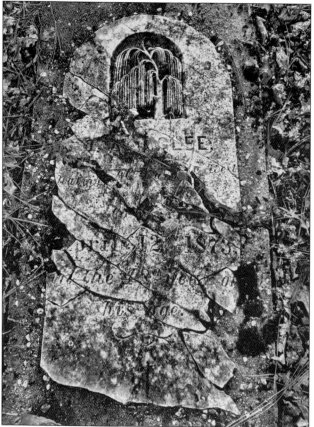

In this rare photograph of Cherokee in 1901, a group of miners, young and old alike, poses for an opportunity to not only capture the moment but potentially purchase a copy of the photograph to send home. The *Poingdestre 1895 Mining Directory* documents the town of Cherokee, noting, "Few of the old buildings still remain." Virtually nothing is left today of this once-flourishing town except the cemetery situated above Shady Creek along the ridge, about four miles east of North San Juan. (Black Bart's Ornamental Iron Works.)

This is the badly decomposing marble gravestone of Canadian miner David A. Inglee. Once toppled and broken, the elements quickly reclaim carved stones. The names, dates, and sentiments depicted on uniquely carved gravestones, like the one shown here, are then lost forever. (CW.)

The graceful geometry of the emblem of the Ancient Order of the United Workmen with its three links indicates membership in the Independent Order of the Odd Fellows. The Masonic compass is also subtly embedded in this artistic work of stone carver W.H. McCormick. (CW.)

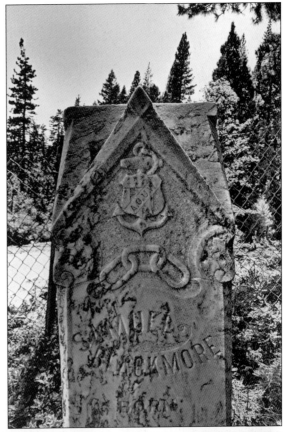

Here is a 2015 view of the Red Dog Cemetery. As late as February 2015, despite efforts to protect the site, the local newspaper reported grave vandalism; the cemetery had been desecrated by grave robbers content in their ignorance and disrespect of cultural heritage. The town blacksmith was commissioned to fabricate and erect the elaborate perimeter fencing around the fraternal order sections, remnants of which still exist as seen here. (CW.)

This is a late 1950s view of Red Dog Cemetery. The first recorded burial in Red Dog was in 1852, though no monument remains. According to Landrith and Duvall's 1987 *Cemeteries of Nevada County*, "The old timers say more than 400 are buried here." One would never know it today, as many of the monuments have either decayed, been broken by tree fall, suffered the indignity of vandalism, or been stolen outright. Less than 50 monuments remain, and much of the ornamental hardware associated with the fraternal orders or family plots has also disappeared. (SHRL.)

Lyle L. White is pictured here in the Red Dog Cemetery in 1959. White worked diligently, giving of his own free time to preserve, restore, document, and raise awareness of the often-deplorable state of the region's pioneer cemeteries. He single-handedly amassed a thorough library with volumes of research data, being of immense cultural and historical importance. His archive is housed in the Searl's Historical Research Library in Nevada City. (SHRL, Lyle White Collection.)

This photograph is labeled "H. Stehr, Red Dog Claim 1880." Henry Jacob Stehr, a ranking Mason, died in 1881. Stehr is pictured against the backdrop of the immensely thick tertiary river deposits the hydraulic and drift mines of Red Dog were immersed in. Stehr, miner and pioneer forefather of Red Dog, was buried in the Red Dog Cemetery on April 17, 1881. (CW.)

Stehr's son Lawrence Myron Stehr (March 16, 1862–August 4, 1873), seen here, also died shortly after this photograph was taken. A victim of a tragic drowning, he is buried next to his father. While looking for his horse, the young Lawrence fell into an open mineshaft. (Fesler Collection.)

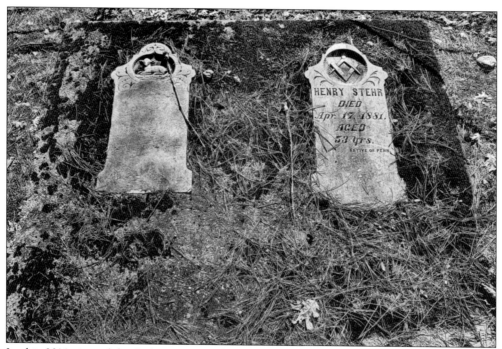

In this 2014 view of the Stehr gravesite, the grave of Henry's son Lawrence is on the left. The gravestone with baby lamb motif is illegible today, nearly washed clean by the elements. Photograph enhancement and proximity context helped positively identify this grave monument. (CW.)

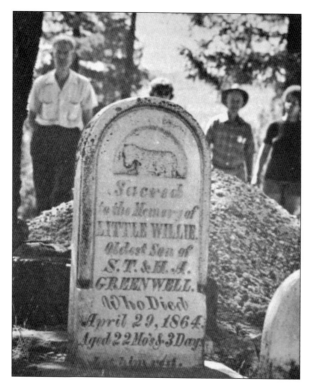

This is a 1966 photograph of the delicate marble grave of Willie Greenwell, just 22 months old when he died accidently by falling into a water-filled flume. As evidenced by this 50-year-old photograph, Red Dog Cemetery has inspired generations eager to feed the imagination with homage to history. Please report criminal activity associated with a cemetery to the authorities and never trade in funerary items—they may be linked to grave robbery. (Sunset Publishing Corporation.)

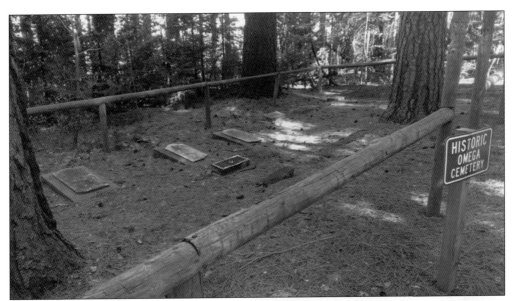

The Omega Cemetery (established in 1853) is pictured here in early 2015. Access to the townsite of Omega (California Historic Landmark No. 629) is currently privately controlled, though the cemetery is accessible to the public. No signs lead to the remote Omega Cemetery, located approximately 25 miles northeast of Grass Valley. This sanctuary is perennially hidden under the canopy of the surrounding Tahoe National Forest and can be difficult to find. (CW.)

Pictured is the abandoned Omega Cemetery around 1960. According to Poingdestre's *Mining Review of 1895*, the initial townsite of Omega and potentially the original associated pioneer cemetery site is not known, as the entire town moved at least twice due to advancing drift and hydraulic-mining activity. The town was first populated in 1850 by a single miner, J.A. Dixon. Little is left but the cemetery to indicate the once-important hamlet of Delirium Tremens. (SHRL.)

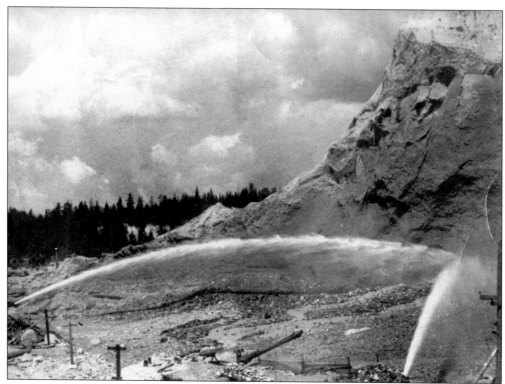

Hydraulic mining is seen in Omega in 1879. Named Delirium Tremens in the 1850s for a division of the Sons of Temperance, by 1853, mining was underway on a large scale. The year 1858 saw the height of Omega prosperity, at which time the town enjoyed at least "four stores, four saloons, a hotel and about 200 souls," according to Thompson & West's 1880 *History of Nevada County.* (SHRL.)

Pictured here is the Omega Cemetery as it appeared after a 1966 cleanup, restoration, and rededication effort by the Masonic California Grand Lodge No. 1. The *Nevada Democrat* reported in March 1858, "The town, like all California towns, is cursed with a few of the sporting gentry and a house of unquestionable bad repute." By November, the first jail, or calaboose, in the area was put into use: "That will have a tendency to preserve order and quiet down the effects of bad whiskey." Later that year, the town was formally renamed Omega. (SHRL.)

Dr. William S. Henderson (1829–1861) is pictured here in 1860. Doctors coming to the Washington Mining District seem to have been interested only in finding gold and practiced their professions as a sideline or only in emergencies, as stated in Slyter's 1963 *Historical Notes*. One exception may be Dr. Henderson. (SHRL.)

This is the grave of Dr. Henderson in the Omega Cemetery. The good doctor often risked his own life and livelihood accounting for the medical needs of Washington Township, a vast area encompassed by rugged mountain terrain often covered by deep snow in winter. The Henderson family first worked the ravines that would become the nearby Alpha Diggins. While it is certain that Dr. Henderson is buried in Omega Cemetery, the exact location of his grave is not known. (CW.)

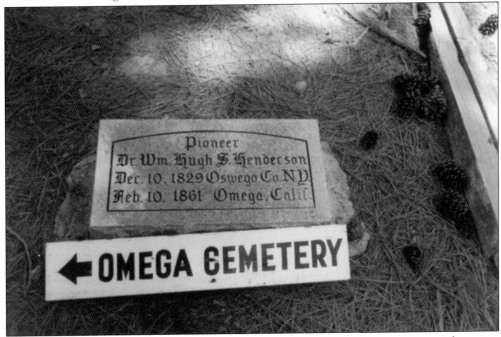

This is a westerly view of the Relief Hill Cemetery as it looked in 2015. The cemetery was established in 1853, the same year the mining camp was settled. The cemetery may be all that is left of the original townsite of Relief Hill, as the town itself has relocated at least twice since it was first established. (CW.)

Relief Hill is pictured here from the northeast in 1890. The cemetery is at the far upper right, above the white hydraulic cut. Rich gold-bearing tertiary gravel deposits brought would-be miners like Captain Monroe in 1853 and G.G. Wolders in 1855. Wolders and his wife, Adelaide, are buried in the nearby North Bloomfield Cemetery. Monroe was a San Francisco Bay pilot in 1850 until news of gold brought on a fit of gold fever, and he soon found his way to Relief Hill. He and his extended family are buried at the Relief Hill Cemetery. (DFLHR, Cameron Larsen Collection.)

Here is a view of the Larsen family plot immediately following a 1970 restoration. Gravestones, now gone, can be seen in the background, and much of the decorative perimeter fencing of the surrounding graves is now missing, possibly stolen. What is left of the once-abundant individual grave perimeter fences are badly damaged by downed tree limbs and snowfall. The touching epitaph of the Jeusine O. Larsen (wife of H.P.) gravestone reads, "Lost to Sight, To Memory Dear." H.P. Larsen's side of the gravestone reads, "Rest in Peace Father Dear." The two epitaphs together create a rhyme. (SHRL.)

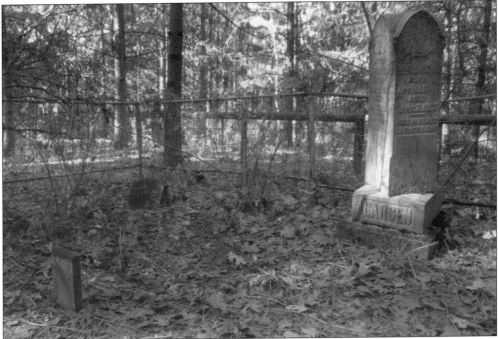

In this view of the Larsen plot in 2015, note that the grave of Lavonne Walch (1903–1907) has been added. The year 1856 brought with it the completion of many mining-related water ditches in the vicinity, a resource very much needed for mining and settlement. With the promise of water, a town was laid out. By 1857, there were 25 homes, a general store, two saloons, a butcher shop, two boardinghouses, and a blacksmith, with more to come. By 1858, some 100 voters and over 11 families lived in Relief. (CW.)

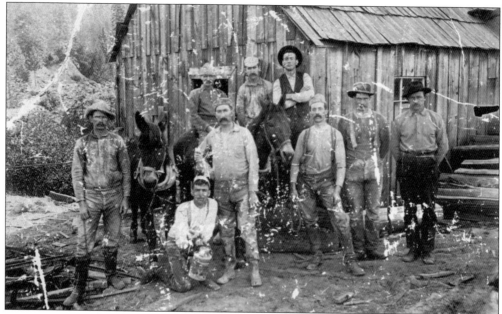

Hans Peter Larsen (1847–1908) is standing at left center with his workmates outside the Waukeshau Mine in Relief Hill around 1895. The Penrose family arrived that year from England. Born in 1826, Elijah Penrose, at far left, would marry Elizabeth Jago and eventually have three sons and six daughters, most of whom were born locally and would one day die working the mines and be buried at Relief Hill, North Bloomfield, North San Juan, and other regional cemeteries. Most of the men in this photograph are interred in the Relief Hill Cemetery. (SHRL.)

This is a 2015 view of the Monroe family plot in the Relief Hill Cemetery. By 1860, the surface placers were all but gone, and the town went into decline, but the hydraulic-mining method was being perfected nearby, and this brought a new era of prosperity to Relief. In 1877, hotel owner Emmanuel Penrose married Mary Jespersen and only three weeks later died of complications of typhoid fever. No monument remains in the cemetery for this pioneer member of the early Relief Hill community. (CW.)

Shown here is a 2014 view of the Penrose family plot at the Relief Hill Cemetery. The Penrose family members are among the pioneer families well represented in the Relief Hill Cemetery and the nearby North Bloomfield Cemetery, among others. The family plot at Relief contains "Mother" Lillie Jane Penrose, the infant Ira Penrose, Elisha Penrose, and likely Emmanuel Penrose. (CW.)

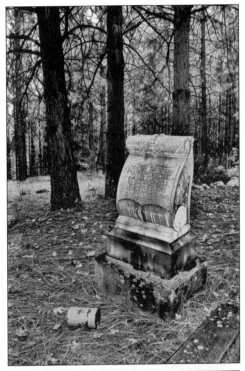

Emmanuel Penrose is shown here with a two-horse freight wagon on Relief Hill Road in the 1870s. In June 1890, Jeusine Larsen, born in Denmark in 1851, a tireless hardworking miner's wife, died of consumption, along with friend Lloyd Beck that same month. The untimely deaths of these two longtime residents quietly signaled the end of what was once a thriving mining town. Both are buried in the cemetery at Relief Hill, with Lloyd Beck inside the Monroe plot. (SHRL.)

Even after the 1884 Sawyer Decision, mining often continued, as depicted here around 1890. Hydraulic mining was taken to the very edge of the Relief Hill Cemetery (at right). There are accounts of crazed husbands, mad with gold fever, set on washing their own home foundations away, while the wives and children fled, escaping certain death, only to watch their home be washed downstream. (DFLHR.)

This is the grave of miner William McDonald, who died during the summer of 1882 of a mining accident at the young age of 22. A native of Nova Scotia, McDonald was survived by his parents, Duncan and Annie. Fittingly, a rusty old gold pan lies at the foot of his grave. The 1980s again brought destruction to the hills of Relief. The pursuit this time was timber, and the cemetery suffered greatly. (CW.)

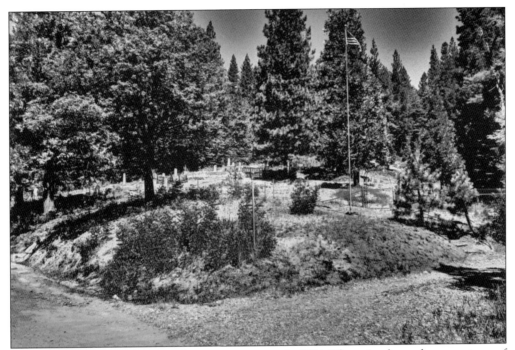

Pictured here is the Forest City Cemetery entrance in 2014. The epitaph on the gravestone of John Prosser near the cemetery entrance reads, "Stop here my friend and cast your eyes. As you are now so once was I. As I am now so you must be. Prepare my friend to follow me." The cemetery is just outside of downtown Forest City, first settled in 1850 by a Mr. Savage. The cemetery was established in 1864 by the IOOF, becoming the first fraternal cemetery but third overall cemetery for the early community of Forest City and its neighbors. (CW.)

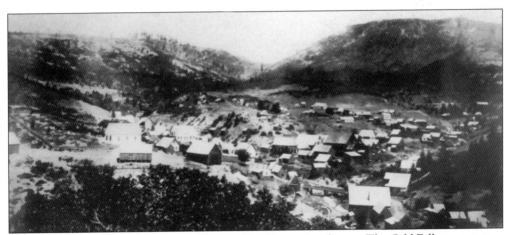

This photograph of Forest City was taken in 1868 from east of town. The Odd Fellows cemetery property (at center left), once included Odd Fellows and Knights of Pythias Lodge No. 32, also seen here. The public cemetery, located farther outside town, became thought of as too far to ask mourners to travel, and in 1870, Lodge No. 32 opened up its cemetery to the entire community. (SCHS)

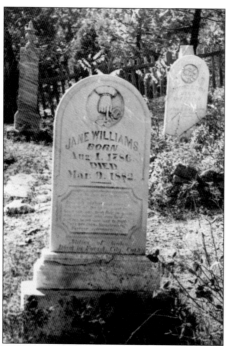

This is the grave of Jane Williams (1786–1882) in the Forest City Cemetery as it appeared in the early 1930s. Her gravestone reads, "She hath done her bidding here. Angels dear! Bear her perfect soul above, Seraph of the skies, sweet love! Good she was and fair in youth. And her mind was seen to soar. And her heart was wed to truth. Take her then forevermore. Forever evermore." (SHRL.)

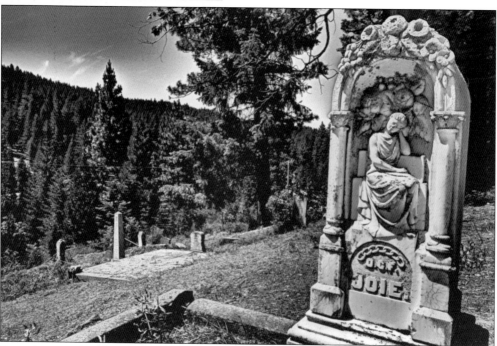

Persephone on her throne sits in guard over this grave with only the name Joie engraved. This may represent Joseph McCormick, who died in 1877. The letters OCF with a length of chain indicate membership in the Order of Chosen Friends. In the United States, OCF was originally founded to pay old-age and disability benefits, acting like an early form of social security. The order formed around 1888, and before internal problems arose around 1900, the OCF had as many as 12,000 members. (CW.)

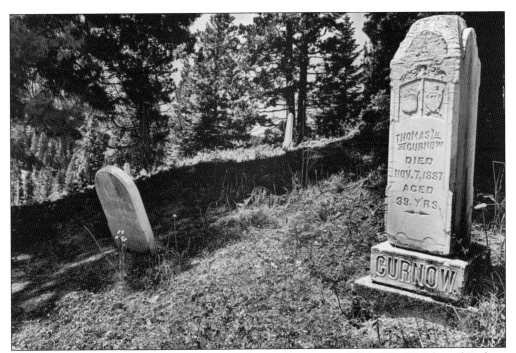

Pictured here is the unique gravestone of Thomas Curnow in 2014. The Knights of Pythias emblem includes a rarely depicted skull and crossbones. The Knights of Pythias, from the Greek name Phintias, was founded in 1864 in Washington, DC, by Justus Rathbone as a secret society of government clerks. The Knights became the first fraternal order to be chartered by an act of Congress. The K of P philosophy is based on the traits of friendship, benevolence, and charity; "FBC" is often emblazoned on Knights of Pythias graves. (CW.)

In this photograph of an 1892 gathering of the Knights of Pythias in Forest City, the cemetery appears in the far background atop the hill. The Forest City cemeteries are rich with preserved depictions of sacred symbols of brotherhoods and sisterhoods of the era with many of the gravestones hand-carved by artisans in Sacramento, San Francisco, or further afield. (Vivian Collection.)

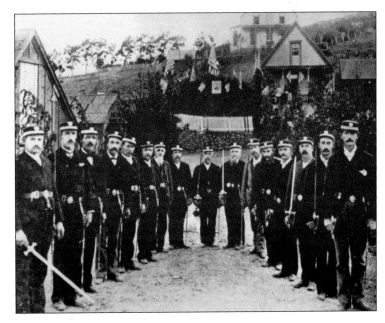

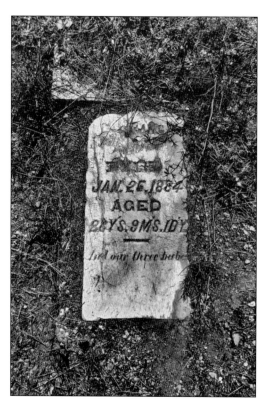

This nameless gravestone that time and the elements of nature and society have robbed of identity is among the most common attributes of a historic cemetery. As seen in this photograph taken in 2015, the entirety of this badly deteriorating gravestone reads "JAN 25 1884, 28Y'S. 9M'S. 1D'Y — And our three babe…" The inscription at the base of the monument ends with the word "babe" with a damaged ending edge, potentially "babes." (CW.)

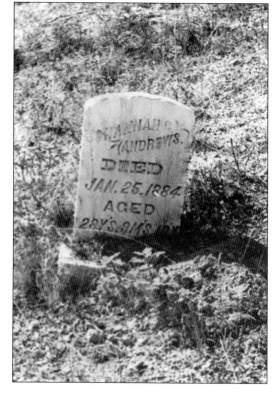

The same gravestone is seen here approximately 85 years earlier. Without someone to visit or maintain the gravesite, the name of the interred can be forever lost—unless an anonymous photographer in the 1930s had taken this photograph before the lion's share of the damage had been done. This photograph captures clearly the name of the buried individual. Enclosed in a floral design is the name "Hannah C. Andrews." (SHRL.)

This 1860 view of Forest City appeared in *Hutchings' California Magazine*, a popular periodical that often showcased artists of the era. To the left of center, along the hill slope, is the Odd Fellows cemetery before the lodge was erected, marked by a white fenced enclosure. This depiction of Forest City is from a wood-block engraving by T. Ayres, a traveling artist who worked with James Hutchings's magazine. (CW.)

Pictured here are the dogwood-shrouded graves of Warren Adams (right) and Clara Homfray. Homfray (died 1863) was the beloved wife of P. Homfray and a native of Herefordshire. Warren Adams was 49 years old (1820–1869) when he died in Forest City. His marble gravestone traveled over 180 miles from San Francisco. Before the Forest City Odd Fellows Lodge No. 32 opened their fraternal cemetery to the general public in 1870, the Pioneer Cemetery, as it is locally known, was the only community burial ground for nearly 20 years. Situated no small distance north of town, the Pioneer Cemetery continued to be used well into the 1870s, but eventually people started using the more accessible Odd Fellows cemetery closer to town. (CW.)

The Pioneer Cemetery for the town of Forest is on federal land within the Tahoe National Forest. It is challenging to locate and equally difficult to explain how to find it. Three miners' shovel-heads stand idle next to the grave of Truman L. Douglas in this northeasterly overview near the entrance to the Forest City Pioneer cemetery, as it appeared in 2014. A native of England and son of Sylvester and Abigail Douglas, Thurman died in 1863, victim of a disastrous mining accident. He was 31 years old. (CW.)

The gravestone of Eliza Johnson, pictured as it appears today, reads, "To The Memory of Eliza. Consort of Thom. Johnson who Departed this Life March 14 1860. Æ. 28 Yrs." Her grave seems curiously set apart from the cluster of eight other surviving monuments (a good 50 feet south of the rest). Complete with initialed footstone, it is very nearly engulfed by the thick Sierra forest of towering Douglas fir, sugar pine, and native dogwood. It is evident the burial ground holds dozens more interments than represented by the nine surviving monuments. So what happened to all the gravestones? Certainly some were lost to the elements, and some to the vandal's hand, but many of the working-class residents of the remote mining towns of the Sierra were often of meager means and could not necessarily afford more than a homemade wooden marker, long-since decayed, leaving no trace. (CW.)

Here is a 2015 view of the Sierra City Cemetery from the entrance. This modestly forested cemetery was established shortly after the founding of the town in 1850, though the earliest surviving grave monument is dated 1866. Most of the burial plots reside on hand-dug terraced platforms, which necessitate elaborate retaining wall construction on the downslope to accommodate decorative perimeter fence adornments, the burial vaults, and grave monuments. (CW.)

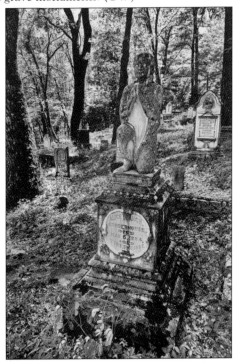

Shown here are the haunting eyes of the grave of Alice Branch Sunderhouse (died 1884), age two years five months, daughter of John and Mary G. Sunderhouse. Located near the center of the cemetery, amongst numerous other child graves, this beautiful statuette of a praying little girl with piercing eyes and burial shroud is a vivid reminder of the steep cost many families paid during the mad rush to the gold fields. In the gold camps of the Sierra, growing to maturity often meant surviving times of malnourishment, epidemic, and harsh living conditions, all in a rugged, unfamiliar landscape. (CW.)

This is the impressive marble obelisk grave monument of Jessie Turner Hanks (1841–1873), superintendent of Sierra Buttes Mine. The Sierra Buttes Mine became one of the most famous and greatest gold-producing operations in the history of Sierra County, lasting over 80 years and second only to the Sixteen-To-One Mine in Alleghany. (CW.)

Pictured around 1870 is Jessie Turner Hanks. A native of Connecticut, he died suddenly at the age of 42 after serving as an early superintendent of the Sierra Buttes Mine. The following poem was left at his grave, author unknown: "If you could see your ancestors all standing in a row, / Would you be proud of them or not or don't you really know? / Some strange discoveries are made by climbing family trees / and some of these you know do not particularly please. / If you could see your ancestors all standing in a row, / There might be some of them you wouldn't care to know. / But there is another question that requires a different view. / If you could meet your ancestors would they be proud of you?" (CW.)

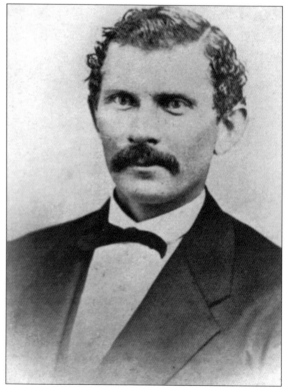

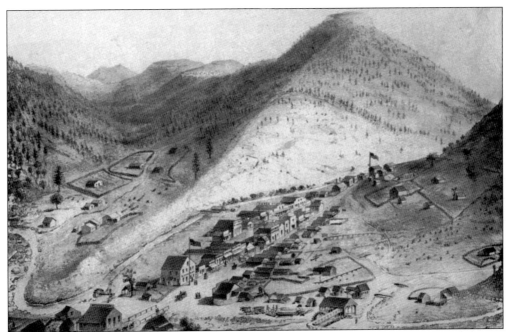

This depiction of Goodyear's Bar was drawn by William Monmanier in 1855 for the Britton & Rey Company of San Francisco. The cemetery is in the distance within a small fenced enclosure to the right of the flag. The cemetery here, which is still in use occasionally, came into being as a result of an erysipelas epidemic in the fall of 1850, making the Goodyear's Bar Cemetery one of the oldest cemeteries in Sierra County and in the region. (LOC.)

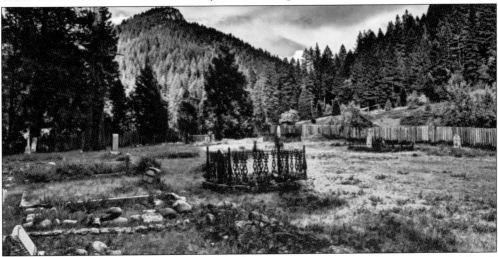

This is a northerly facing overview of the Goodyear's Bar Cemetery with the prominent landmark Monte Cristo in the distance. When first settled in the summer of 1849 by Miles and Andrew Goodyear, with a Mr. Morrison and a Dr. Vaughn, Goodyear's Bar, as it became known, was part of a young Yuba County until 1852 when Sierra County was created. Miles Goodyear was buried in the town of his name, and according to Sinnot's *History of Sierra County Volume II*, "It is said that his coffin was an old [placer gold] rocker and a buffalo robe served as the shroud." Goodyear's body was later disinterred and brought to Benicia, California, for reburial next to his brother Andrew. (CW.)

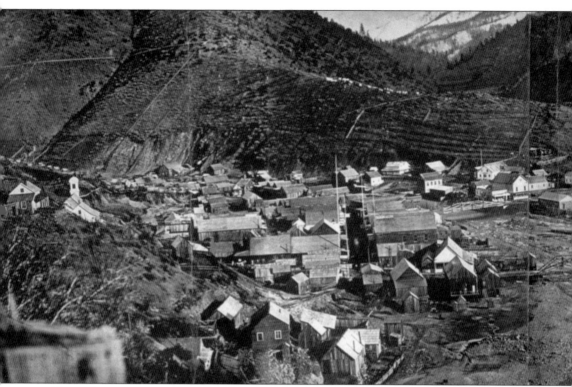

Shown here is a view of Downieville with the original cemetery site pictured on the hill above town at center. The original Downieville Cemetery, often called the Masonic Graveyard, was first established around 1860. Both working-class family burials and ornate burial plots of local dignitaries alike were washed away by mining and periodic seasonal floods. The *Mountain Messenger* records in 1865 that a party of miners began a multiyear process of moving the remains and monuments to their current location: "The ground had been mined all out to the bedrock so far into the burial grounds that some two or three coffins are now protruding, some of them half their length." Even the current location was not high enough on the hill to avoid the flood of 1937, at which time many graves were lost and washed downstream. (LOC.)

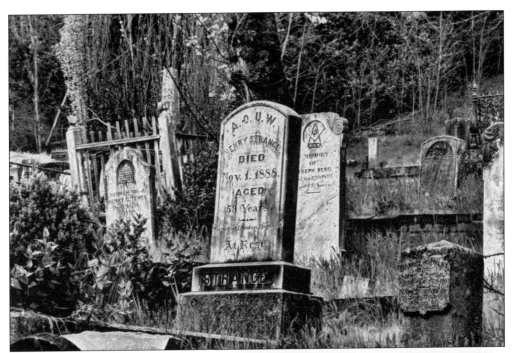

Many elaborate Masonic graves and those of numerous fraternal orders are represented in the Downieville Cemetery. In this photograph taken in 2015 from near the grave of Henry Strange, the icons of at least three secretive orders are represented. At left, at the grave of Hannah Lewis, a beehive is depicted, representing membership in the Ladies of the Maccabees, the first fraternal benefit group run entirely by women. At center is the affiliation of Henry Strange. The "AOUW" represents the Ancient Order of the United Workmen. Finally, at the grave of Joseph Berg, the compass and three chain links indicate Masonic and Odd Fellow membership. (CW.)

The Wagner Noland grave with epitaph reading "Our Children," depicts a stylized Knights of Pythias insignia. The Byington grave, situated near the center of the cemetery, is crowned with a striking rendition of the archangel Gabriel writing the names of the recently deceased in the book of life. (CW.)

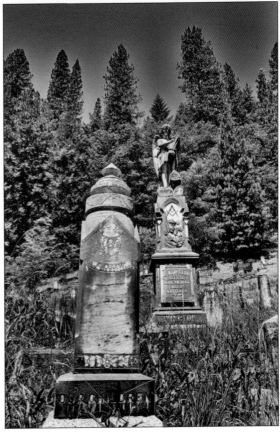

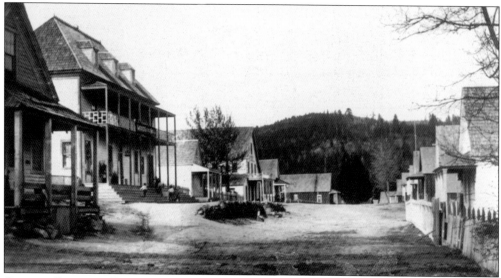

Graniteville, originally Eureka, then Eureka South, is located almost 30 miles north of Nevada City and was first settled in 1850. Situated near the summit of the Sierra Nevada, the gold diggings here once sustained a burgeoning community, attracting around 1,000 residents by 1856, but exhaustion of surface placers led to a population decline. (SHRL.)

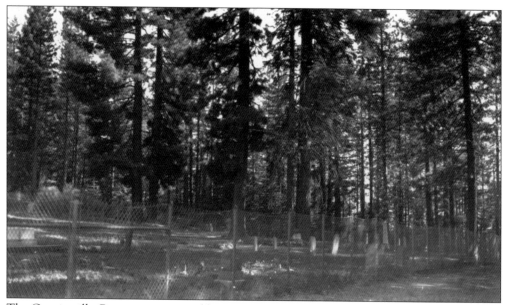

The Graniteville Cemetery is pictured here in 1965. In 1860, Eureka South was recorded as one of the liveliest towns in the county, but by 1866 the town had only 20 residents. The discovery of gold-bearing quartz ledges gave the town a renewed vitality in the late 1860s. By 1870, Graniteville emerged as an essential distribution point for water, indispensable to downslope hydraulic-mining operations in towns like Malakoff and Relief. The population surged during this time. By the mid-1880s, the town was deteriorating. This cemetery, established in 1855, is still in use and maintained by cemetery district and volunteer efforts. (SHRL.)

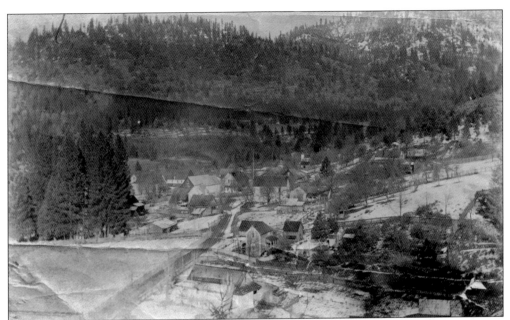

Shown here is a snowy overview of Washington around 1910, with the cemetery on the left in the group of tall pine trees. The little town of Washington, situated astride the South Yuba River about five miles from North Bloomfield, is one of the earliest settled camps in Nevada County. In late 1849, the area was denoted as Indiana Camp and referred to as a flourishing settlement. Early 1850 brought thousands of prospectors, but by the following winter, many were discouraged by the absence of any remaining placer deposits and left. Hard-rock mining brought a resurgence to Washington, and by 1851, around 3,000 people were estimated to live there, including a large population of Chinese and some Native Americans. (Washington Museum.)

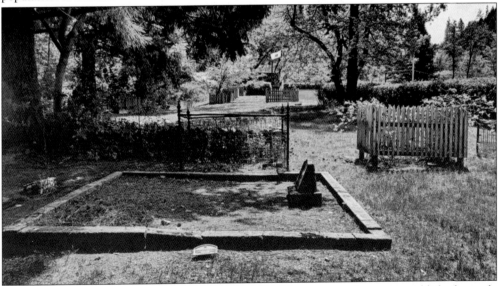

The cemetery of Washington is pictured here in 2014. The cemetery here was established as early as 1852, according to the local cemetery district, and holds numerous burials that date from the 1850s. The cemetery grounds in Washington seem curiously small for the large historic community it served. There are only 112 known burials to date. (CW.)

The Chinese cemetery of Washington Township is pictured around 1911. It lay immediately outside and downstream of Washington. Only a few broken bricks from the *chitan* (offering oven) are left to mark the spot. The last remains of those interred there are said to have been exhumed in the 1920s. The 1860 census marshal's report lists 620 Chinese (2,100 Caucasian) in Washington Township, a number thought by local historians to be immensely miscalculated or underrepresented. (Washington Museum.)

North Bloomfield is pictured here around 1870. The North Bloomfield Cemetery, now located within the Malakoff Diggins State Historic Park, is nicely maintained by the Nevada Cemetery District and volunteers. Once a part of the largest and most important settlement of the immediate region, the area around North Bloomfield was home to the nearby Malakoff Hydraulic Mine, one of the largest hydraulic mining operations the world has ever seen. (SHRL.)

The North Bloomfield Cemetery, with numerous unmarked or no longer marked grave depressions, may have been established as early as 1851—though the earliest surviving grave dates to 1857. The communities of Lake City, Derbec, North Bloomfield, Backbone, Relief Hill, Columbia Hill, and Malakoff all used the cemetery grounds. North Bloomfield is noted as one of the only cemeteries with surviving examples of ornate wooden monuments, as seen here at the grave of Katherine Victor, who died at the age of 62 in 1878. (AG.)

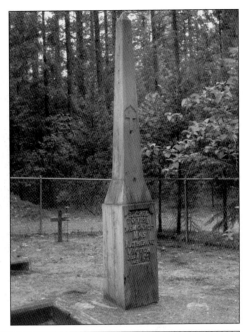

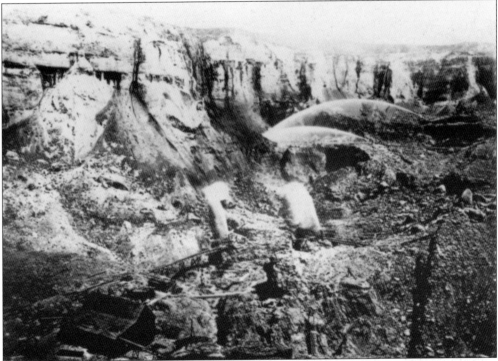

Pictured here is Malakoff Diggins in 1881, three short years before the hydraulic monitors were somewhat silenced by the historic Sawyer Decision of 1884. Originally named Humbug City, the vicinity was initially prospected in 1851, and by 1855, the village of Malakoff was settled. By 1857, Malakoff boasted a population of at least 500. Malakoff, a name given by early French immigrant miners, was an homage to the victory at Malakoff Hill in France during the Crimean War. By 1876, the recorded population was 2,000. (SHRL.)

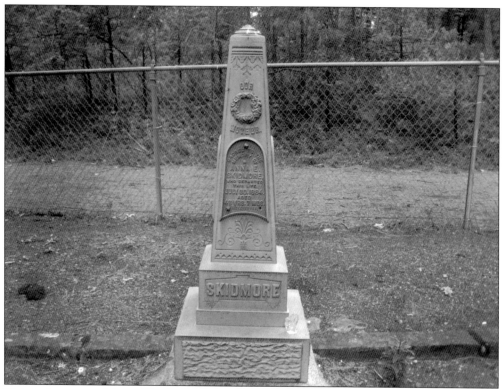

This is the grave of Anna Elizabeth Skidmore, wife of Rush "R.D." Dix Skidmore, and mother to five children. A native of Germany, Anna married Skidmore in 1862. By this time, R.D. Skidmore already owned the town bakery and a saloon and had built a livery stable. His home, built in 1860, was located across from the Kallenberger barbershop and is where the couple raised their children. Their daughter Mary Katherine Skidmore married William Henry Kallenberger in 1884. R.D Skidmore died in 1911 after a lingering illness. Anna Skidmore died in 1884 at the age of 43. (AG.)

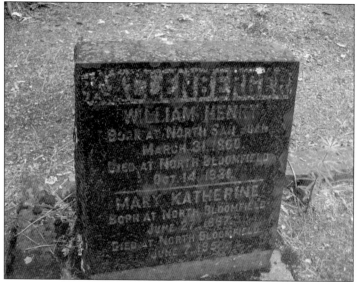

This 2015 photograph shows the graves of William Henry Kallenberger and his wife, Mary Katherine Skidmore. William was born in North Bloomfield to George and Louise Kallenberger in 1860. He died in North Bloomfield in 1931. Like his father, he was a barber but also listed his occupation as a miner. His wife was also a native of North Bloomfield. (AG.)

Seen here is the grave of the notorious Alfred Powell. Born in Vermont in 1837, he came to work for the Malakoff Company in 1853 and amassed a decent amount of wealth. He left for the East Coast and invested his fortune in a business, which he rather quickly lost. Broke, he returned to the North Bloomfield area to try his luck again. Unfortunately, according to Loni Patterson's *Forgotten Pioneers*, he suffered from paranoid delusions, including visions of creek banks collapsing on him. In late January 1880, he was found in his own bed in North Bloomfield with his throat slit—the victim of an apparent suicide, it was reported. (AG.)

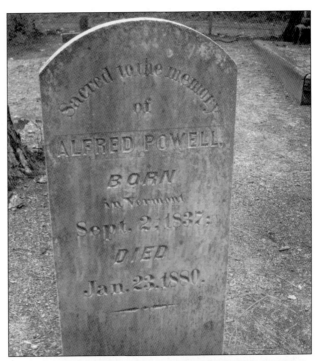

George Edwards (1828–1885), born in Denmark, died in 1885 at the age of 57 as a result of a third and final stroke, related to "quicksilver intake" according to Loni Patterson's *Forgotten Pioneers*. A Mason and accomplished carpenter, he came to North Bloomfield in 1857. In 1862, he built a hotel at Malakoff, which burned down in 1875. He married Mary O'Conner, with whom he had six children. He built the Grand Central Hotel in 1876, which also burned down in 1878. He rebuilt a three-story hotel in Malakoff, which burned again in 1885. His epitaph reads, "Gone but Not Forgotten." (CW.)

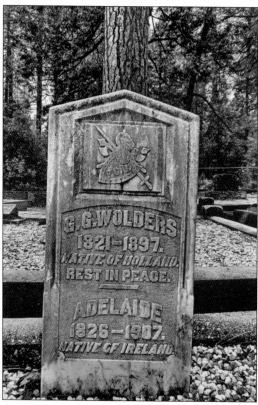

Buried together, Adelaide and Graders Wolders died within months of each other. Exactly how they met and married is somewhat of a mystery. G.G. Wolders of Holland was a Knight of Pythias and a Dutch sailor in the East Indian Ocean in the late 1830s when his assigned vessel, the *Osceola*, shipwrecked and set the young Wolders adrift for nine days in the open sea. He was miraculously picked up by a passing British vessel and eventually arrived in Yerba Buena in 1850. By 1855, he had caught the gold fever and eventually became one of the founders of American Bar Mining Company at Relief Hill. (CW.)

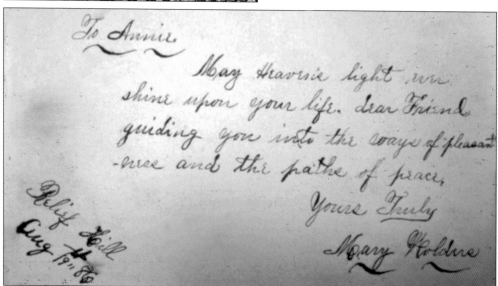

Adelaide was born in Ireland in 1826 and came to California by way of Australia in 1867 with the surname Keagan. She was presumably widowed, having had two sons and a daughter with Keagan prior to marrying Wolders. Adelaide was recognized in 1908, just prior to her death, as a Daughter of the American Revolution. The Wolders had a daughter together named Mary. Here is an excerpt from the 1886 *Diary of Annie Penrose Peterson of Relief Hill*, written by the daughter of Mary Wolders. (SHRL.)

Pictured here is the grave of the beloved Dr. Leland S. Lewis; on the right is his wife, Sarah "Sally" Lewis. She is now interred here alongside her husband and family. Looking closely, one can see her death date is yet to be engraved. (SHRL.)

Pictured here is the grave of Dr. Lewis, a member of E Clampus Vitus, who was instrumental in helping the area of North Bloomfield become recognized as a historic site worthy of protection, assisting in the foundation of the State Historic Park at Malakoff. Like her husband, Sally was also very active in her community, as evidenced by an additional local memorial, offered by the Nevada City Women's Civic Club, found alongside Little Deer Creek in picturesque Pioneer Park, Nevada City. She died on March 12, 2000. (CW.)

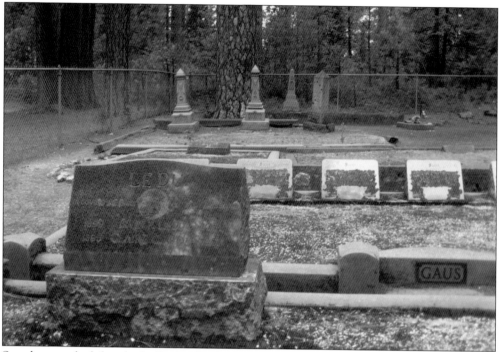

Seen here on the left is the Le Du family plot, located just in front of the Gaus plot. Francis Le Du married Lillie Ann Gaus in 1897, and together they had seven children: Irwin, Wendell, Everand, Arnold, Dellorez, Mercedes, and Lillian. Visible just beyond the Gaus plot are the Kallenberger/Skidmore graves. (AG.)

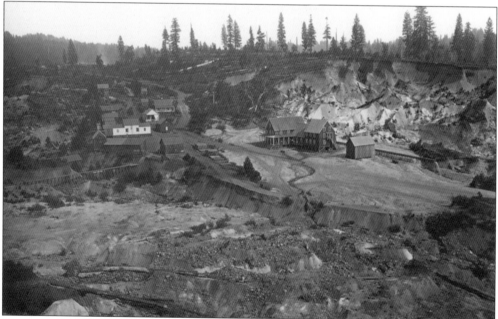

Mining in Malakoff was underway full-scale by the time Carleton Watkins took this photograph around 1871. Hydraulic mining forced the realignment of roads, dictated the boundaries of settlement, and caused astonishing environmental destruction, as clearly illustrated here. (LOC.)

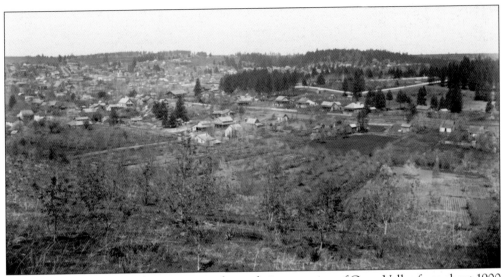

The upper right corner of this unique northwest-facing overview of Grass Valley from about 1900 shows Cemetery Hill, as it became known to locals, the site of the first city cemetery in addition to the burial grounds of multiple fraternal orders. The cemetery is seen inside a handsomely crafted white fence atop Badger Hill. The towering Watt Monument—Masonic Friendship Memorial is seen near the cemetery center. (SHRL.)

This is an 1879 Quirk & Co. photograph of the dedication and unveiling of the Friendship Memorial in the Masonic section of the historic Elm Ridge Cemetery in Grass Valley. This massive memorial of Griffith's Penryn Quary granite was carved by Aitken & Co of Sacramento and commissioned by the Watt family and the Masons, including contributions from local Madison Lodge No. 23. William Watt held numerous historically significant titles. He was a miner in the mid-1850s who eventually was instrumental in the founding of the narrow-gauge railroad and roads system of early Nevada and Placer Counties, and went on to become a state senator. (SHRL.)

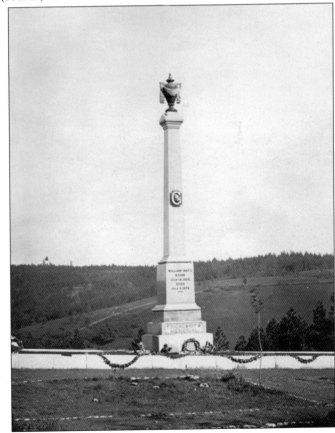

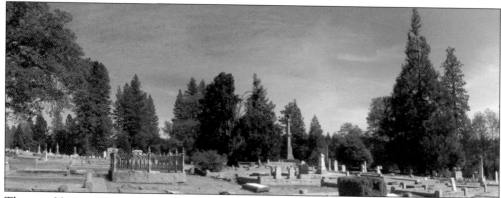

This is a 2014 east-facing view of the Masonic and Odd Fellows section of Grass Valley's oldest surviving public cemetery, established around 1856 with the burial of six-year-old Charlotte Ann Vanslyke, according to the papers of W.C. Pope, considered Grass Valley's first undertaker. However, the cemetery was in use years before it was officially surveyed by the fledgling city. In at least one example, Madison Lodge No. 23 recorded deaths of brethren here as early as 1854. W.C. Pope was also one of Grass Valley's earliest furniture salesmen (specializing in coffins/caskets) and also ran a very successful auction house in downtown Grass Valley. Note the landmark Watt Monument in the background.

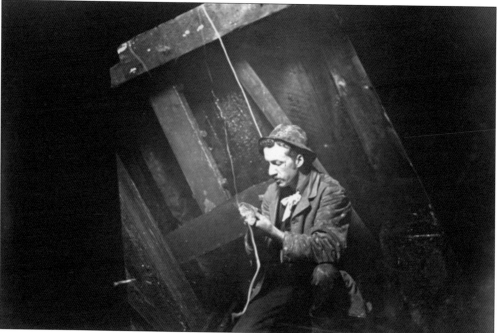

This is a self-portrait of Victor Dorsey underground in the Maryland Mine. Dorsey, in addition to being the trusted superintendent of the Idaho Maryland Mine outside of Grass Valley during the 1890s, was also a gifted photographer. He specialized in outdoor photography and captured many interesting natural scenes throughout the Sierra. The orders of United Workmen, Masons, Evening Star, Odd Fellows, Daughters of Rebekah, Foresters, Mystic Shrine, Woodsmen, Red Men, Knights of Pythias, Knights of Columbus, Moose, Elk, Lion, Beaver, and numerous other fraternal and secret orders are all well represented in the Elm Ridge and old city of Grass Valley cemeteries, in addition to many veterans' memorials and even a lost Chinese cemetery. (SHRL.)

Pictured here is the Elm Ridge Cemetery grave of prominent local figure, miner, and photographer Victor Dorsey (1867–1895) as it appeared in 2014. A poem is engraved in the space below his name: "I rest my soul on God's immortal love and Fatherhood / And trust him / As his children should." Additionally, the gravestone reads, "Accidentally killed while in the discharge of his duty as Superintendent of the Maryland Mine." (CW.)

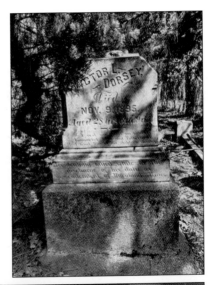

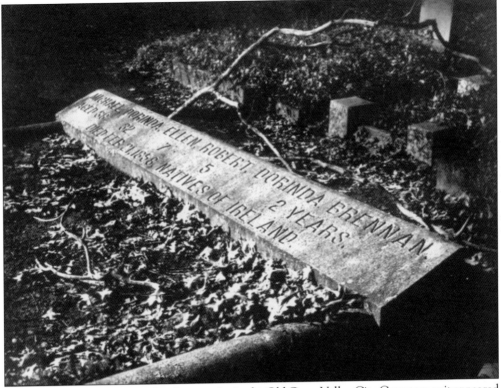

Pictured here is the Brennan family gravesite in the Old Grass Valley City Cemetery as it appeared around 1920. The gravesite has changed little over the decades; on it are engraved in granite the names of the entire immediate family of Michael Brennan. On Sunday, February 21, 1858, Brennan, his wife, and three children (the entire family) were found dead at the family residence in Grass Valley. The corpse of the murderer, Brennan, lay on the floor of his parlor, the body of his wife on a sofa in the same room. The three lifeless children were in adjacent rooms, along with the dead family hound. Prussic acid was the murder weapon, which Brennan had procured out of town. (SHRL.)

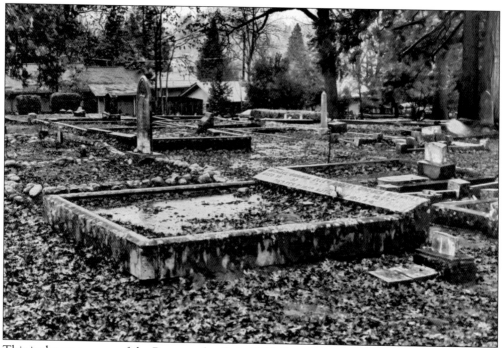

This is the mass grave of the Brennan family in 2015. Found by Brennan's side was a loaded and cocked pistol, which it is reasonable to suppose he intended to use to take his life in case the poison failed, or planned to use on anyone who detected him in his cruel act. He left a letter explaining himself, complaining of his bad luck, asserting that he could not bear the thought of leaving his wife and children to a "buffet of disgrace and poverty." In the letter, he also expressed regret that he was unable to take his mother and a sister in Europe, who were dependent upon him for aid, with him on his morbid journey. (CW.)

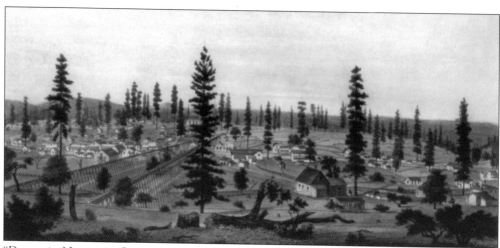

"Drawn in Nature on Stone," is the title of this depiction of a young and bustling North San Juan around 1858 as seen through the eyes of visiting artist Kuchel & Dresel of San Francisco. The North San Juan Protestant Cemetery near the end of Cemetery Alley holds the remains of hundreds of individuals worthy of numerous stories, as does any historic cemetery. According to officials, the cemetery here was established around 1851. (LOC.)

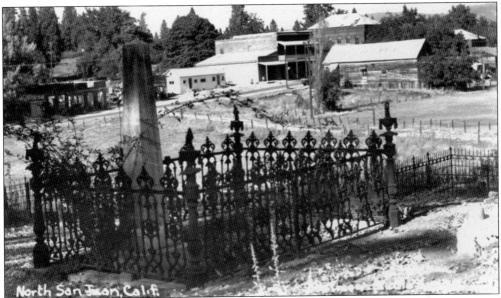

This is a mid-1940s overview of the North San Juan Protestant Cemetery near the grave of William Ellis. The name San Juan was bestowed by Mexican-American War veteran Christian Keintz, who settled there in 1853. He thought the site looked like San Juan de Ulúa near Veracruz, Mexico. When the post office opened in 1857, "North" was added, distinguishing it from a San Juan already in existence in Southern California. (SHRL.)

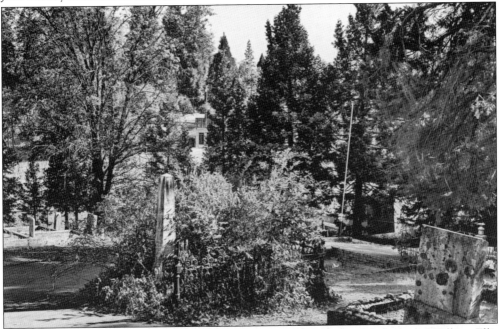

The dramatic change over time is evident in this 2014 photograph of the grave of William Ellis taken from the viewpoint of the previous 1940s-era photograph. In 1859, the *Hydraulic Press* reported that the Eureka Mining Company "cleaned up forty pounds of gold in a twelve-day period" from the hills around North San Juan. In 1867, the town was included on the route for the world's first long-distance telephone line. (CW.)

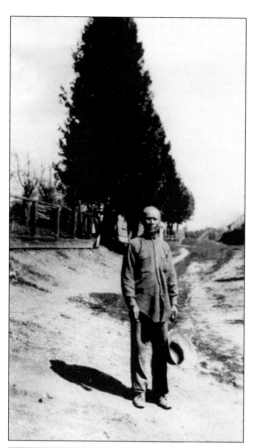

Pictured here around 1900 is Sin Get, also known as Ah Get, though better known as "Smiley." Smiley was 14 when gold was discovered in California. He likely entered California as part of an early Chinese trading company. For nearly 40 years, he worked for the National Hotel in North San Juan and hotels in nearby Cherokee. Smiley resided in North San Juan's Chinatown and was the last local knowledgeable in Chinese funerary customs, a burial practice he voluntarily provided to fellow countrymen. Sin Get was a generous man, gathering from his meager earnings small trinkets, which he gave away to the local children during the Christmas season. (SHRL.)

Shown below is the grave of Sin Get in the mid-1940s. Smiley died on October 17, 1933, at the age of 98. Flowers and assorted herbal offerings are still left at his gravesite in the North San Juan Protestant Cemetery to this day. He was the only Chinese to be buried there at that time. With the Chinese Exclusion Act of 1882, Chinese were banned from Christian cemeteries. (SHRL.)

Oliver Perry Stidger, pictured here around 1880, was a judge and newspaper editor of the *North San Juan Times*, *Nevada Daily Gazette*, and later the *Marysville Herald*, a publication that supported the Whig Party. Col. Richard Rust (buried in the historic Marysville City Cemetery), editor of the *California Express*, was a staunch Democrat, and in 1853 he challenged Stidger to a duel. The two met near Yuba City and used revolvers at a distance of 10 paces. Stidger's shot missed Rust, and Rust's hit Stidger's coat pocket. Rust, however, insisted the duel continue. The second shots also resulted in no injuries. Stidger refused a third try and walked off the field. (YCL, California Room, Public History Archives.)

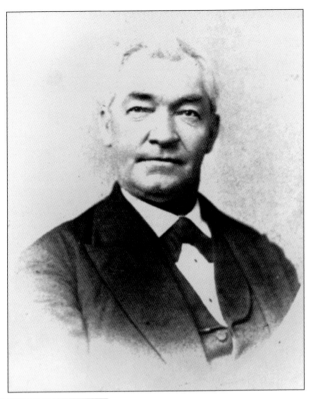

This is the unmarked grave of Oliver Perry Stidger, with Charles Weinman in the 1940s. Weinman was a witness to the Rust-Stidger duel and attended the funeral procession for Stidger. O.P. Stidger died in 1888 after many successful and not-so-successful ventures in Nevada County. He was honored with a funeral parade on the Fourth of July in North San Juan, where he was laid to rest in the Protestant Cemetery. Stidger's grave was rediscovered in 2014 by the author, aided by this photograph. (YCL, California Room, Public History Archives.)

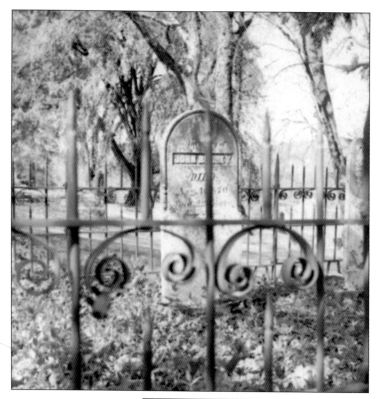

Shown here is a 1930s view of the Bonney grave plot. John Bonney, who died in 1870, was a miner and father of the well-known William Bonney, who died the day after Christmas in 1876 at age 19. Despite the testimony of a few historic cemetery enthusiasts, this is not the grave of the infamous highwayman and gunslinger of Western lore known as "Billy the Kid." Many mistaken visitors have come to the gravesite of these two miners. Regrettably, maybe because of this misnomer, the graves have been the victim of periodic theft and vandalism. (SHRL.)

Shown here is the grave of James Thomas (1819–1858). An incredible array of touching and poignant epitaphs adorn the grave monuments of numerous individuals in the North San Juan Protestant Cemetery. Clearly visible when this early 1930s photograph was taken is Thomas's inspiring epitaph: "Fix my new heart on things above and then from earth release. I ask not life but let me love and lay me down in peace." The inscription has since vanished. (SHRL.)

This is a mid-1920s view of the grave of Callistie S. Kean in the Rough and Ready Cemetery, established around 1851. The first nonindigenous settlement here was made in 1849 by the Rough and Ready Company. Their leader, Capt. A. Townsend, named the company after Zachary Taylor, the recently elected US president. In April 1850, the town hoped to rid itself of mining claim taxes and an alcohol prohibition. Articles of secession were drawn up, forming the Great Republic of Rough and Ready, becoming the only California town known to have seceded from the Union. Almost three months later, when discussing upcoming Independence Day celebrations, community members regretted the secession; it was then rescinded by popular vote. (DFLHR.)

St. Canice Catholic Cemetery in Nevada City is pictured here in 1927. The cemetery was established in 1867, the same year St. Canice Church in Nevada City was founded. The church is named after one of the so-called Irish apostles, Saint Cainnech, familiarly known as Saint Canice in Ireland. (SHRL.)

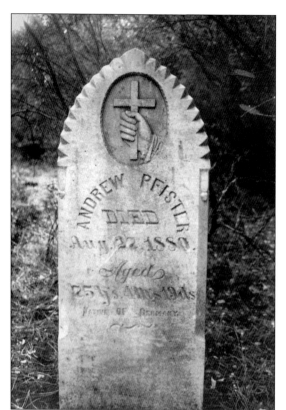

The grave of Andrew von Pfister is seen here around 1950 in the Moore's Flat Cemetery. The cemetery was established around 1853 and is situated deep in the Tahoe National Forest. This town was founded by H.M. Moore in 1851, and by 1880 it was considered a key trade center with a year-round population of 500. It is the birthplace of Isaac Zellerbach, founder of the San Francisco–based Crown/Zellerbach Corporation. Almost nothing is left of this Gold Rush town except the incredibly hard to find cemetery. By 1895, hydraulic mining was curtailed by overwhelming restrictions, and the village was all but abandoned. (Stevenson Collection.)

Here is a portrait of Andrew von Pfister (1805–1880) from about 1875. By 1880, von Pfister was quite ill. He was 75 years old and did his best working as a gardener, but in the end, illness robbed him of his health. He died that year in North San Juan and was transported to Moore's Flat for burial. Interestingly, in or around 1890, the cemetery had to be moved due to advancing mining operations. Upon moving one particular casket, the grave diggers were curious as to why it was so heavy. The coffin was opened and the body, through an unknown process, was reported to have been completely turned to marble. The nameless woman lay there perfectly preserved and in the unspoiled black lace funeral dress she was buried in 20 years before. (Stevenson Collection.)

This is a portrait of John Rollin Ridge (1827–1867) from about 1860. Ridge was a novelist, poet, and member of the Cherokee Nation; his Cherokee name is Cheesquatalawny, or Yellow Bird. Born in Georgia, he was the son of John Ridge and the grandson of Major Ridge, both of whom were signatories to the Treaty of New Echota (Georgia), which Congress affirmed in early 1836. The treaty eventually served to annex Cherokee lands east of the Mississippi River and ultimately led to the Trail of Tears. In 1850, Ridge joined in the California Gold Rush. (YCL, California Room, Public History Archives.)

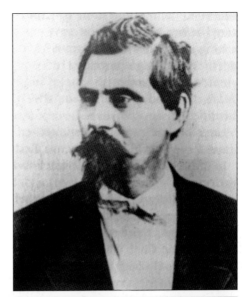

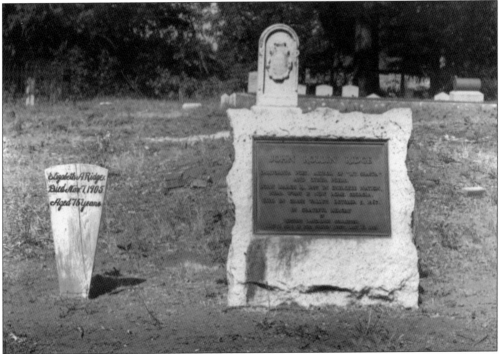

This is the grave of John Rollin Ridge in 1932, in the historic section of the Greenwood Cemetery in Grass Valley. Ridge's writing career began with poetry, then essays for the Democratic Party and regional newspapers, before penning what is now considered the first Native American novel and the first novel written in California, *The Life and Adventures of Joaquín Murrieta: The Celebrated California Bandit*. After the Civil War, Ridge was invited by the federal government to head the Southern Cherokee delegation in postwar treaty proceedings. Despite his best efforts, the Cherokee region was not admitted as a state to the Union. In December 1866, he returned to his home in Grass Valley, California, where he died of "brain fever" (encephalitis lethargia) on October 5, 1867. (YCL, California Room, Public History Archives.)

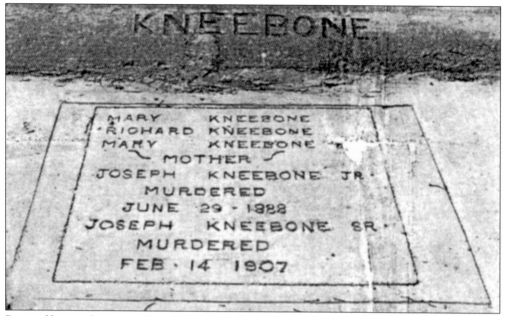

KNEEBONE

MARY KNEEBONE
RICHARD KNEEBONE
MARY KNEEBONE
∼ MOTHER ∼
JOSEPH KNEEBONE JR
MURDERED
JUNE 29 - 1888
JOSEPH KNEEBONE SR
MURDERED
FEB · 14 1907

Pictured here is the grave of Joseph Kneebone Sr., his wife, Mary, sons Joseph Jr. and Richard, and daughter Mary as it looked after a federal government redesign around 1951. Between 1950 and 1951, the government began to bulldoze numerous historic gravesites that fell within what would become Beale Air Force Base. Cement slabs were poured over graves and monuments removed in order to "protect" the burials. In 1888, Joseph Jr. was shot dead along Spenceville Road. Then, 19 years later, his father, Joseph Sr., was found dead of gunshot wounds in the yard of the family ranch near Spenceville. Little motive was established in either murder. The crimes were never solved and the murderer(s) never apprehended. (Bee Superior California News.)

Joseph Kneebone Sr. and his 26-mule team are pictured here in the 1880s. Bells were hung above the lead pair and used to signal other wagons when navigating blind turns along the dangerous stage routes of the region. A team this size would eat approximately 800 pounds of hay every day. (YCL, California Room, Public History Archives.)

This is a portrait of Alonzo Delano from about 1854. Delano was born in New York, the 10th of 11 children. He is attributed as the father of what would become known as "California Humor" and would influence numerous writers of his day, including a young Samuel Langhorne Clemens. (CW, Crabhorn Press Collection.)

Here are the graves of Alonzo Delano and his first wife, Mary Burt, around 1930. In 1855, Grass Valley elected its first treasurer, Alonzo Delano, already the town's Wells Fargo agent. Thompson and West's 1880 *History of Nevada County* describes the conflagration that seized the city in 1855: "Delano, quite dramatically, before the disconsolate residents of Grass Valley, wheeled a tiny shed to the location of his now-incinerated Wells Fargo Office, near the epicenter. Delano posted an 'Open for Business' sign and this crude structure would serve as a temporary office." Delano gave the community hope with this action, and they would never forget. In September 1874, Delano died suddenly. The entire town shut down for the day, and virtually the whole community attended his burial at the city's Greenwood Cemetery. (YCL, California Room, Public History Archives.)

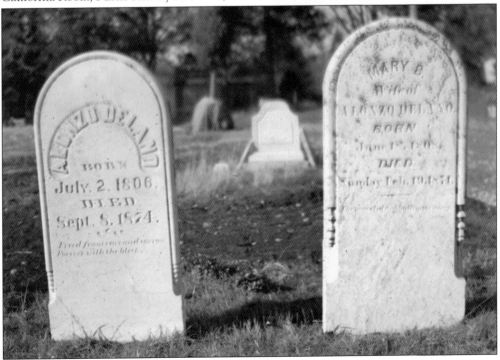

This is an extremely rare view of St. Patrick's Catholic Church (disassembled in the 1940s) and Cemetery with Mount St. Mary's Orphanage, around 1865. The cemetery, established in 1853 by Rev. John Shanahan, is also the site of the first Catholic church and school of the area, there between 1858 and 1879. By 1908, the cemetery was full, and many of the graves were relocated to the new St. Patrick's Cemetery in western Grass Valley. (GVM.)

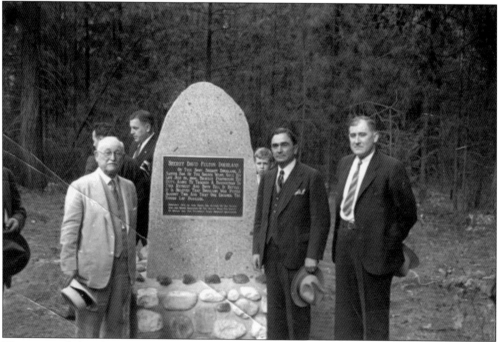

The grave of Sheriff David Fulton Douglass is pictured here during the memorial dedication in 1936. This lone grave commemorates Sheriff Douglass, a Native Son of the Golden West, who on this spot was gunned down in the line of duty in July 1896. Alone, he tracked a violent criminal to this remote area north of Nevada City. It is believed that the sheriff was pitted against two, and one escaped. Two bodies, the outlaw and Douglas, were found laid suspiciously parallel to one another. (SHRL.)

Pictured here is the grave of the young Thomas T. Ralston in late 2014. Behind the historic Kirkham family ranch northwest of Nevada City is the lone grave of the five year old, who died tragically at home on November 23, 1861. Thomas climbed into the attic and fell through the canvas ceiling to the floor below, dying on impact. His broken-hearted parents buried him on the hill above the house. His father chiseled a monument from a common fieldstone and inscribed it with the initials TTR. Today, the stone has disappeared; in its place is the monument seen here. This new monument was placed by an anonymous benefactor. (CW.)

Pictured here is the grave of Lewis Khord in 2015. Khord and a companion were traveling the Emigrant Trail sometime in 1851 when they stopped to camp. Khord was found to have died during the night, and his friend buried him along the trail. (CW.)

Pictured is the Nevada City and County Hospital around 1900. The hospital and associated indigent and patient cemetery has undergone numerous revisions in its 150-plus-year history. Over the years, the facility has served as homeless shelter, hospital, mental health and welfare offices, inmate housing, and a morgue. In 2001, the hospital experienced a tragic shooting. A visiting mental health outpatient suffering delusions opened fire in the facility, killing two. He then drove to a nearby restaurant and killed another innocent. Despite this, the hospital remained open until 2006. (DFHRL.)

The hospital site now stands abandoned. The historic Nevada City and County Hospital Cemetery pictured here is the first of two hospital cemeteries. The cemetery established for patients in 1890 is abandoned, and located near the headquarters of the Nevada Cemetery District. (CW.)

Three

PLACER COUNTY, YUBA COUNTY, AND SUTTER COUNTY

A lone sentinel cypress greets visitors to the Colfax Indian Cemetery, a distinctly unique burial ground. The cemetery is an unassuming meadow of remembrance, kept solemn and comforting, along a quite frontage road interrupted occasionally by sounds drifting in from nearby Interstate 80. No origin date or exact burial number has been established for this cemetery of fewer than 70 visible internments, though several monuments date to the early 1860s. Many monuments are wooden and still many more may have no remaining monument—or perhaps never did. (CW.)

This 1860 advertisement touts Aitken & Luce gravestone carvers, popular throughout the Sierra. Andrew M. Aitken was born in Scotland and immigrated to the United Stated in 1832. He came to California in 1849 and worked a few years in the southern mines before meeting mason Israel Luce. In 1854, he established Aitken & Luce Stone and Marble Works in Sacramento, where he continued his work into the late 1890s. (YCL, California Room, Public History Archives.)

Louis D. "Chief Lalook" Kelly (1886–1980) is pictured in 1968. Kelly, said to have been fluent in at least eight native dialects, was known to many as the last Maidu headman and "father of the last members of the Oustomah." Born on July 7, 1886, at the *campoodie* (native settlement) near what is now Nevada City to Daniel and Lilly Westfield Kelly, his grandmother was the renowned basket weaver Betsy Westfield. Kelly and his wife, Naomi, lived in Nevada City, where Louis worked for the department of public works for 30 years until he retired. (DFLHR.)

This is the grave of Louis Kelly in late 2014. The last Maidu headman associated closely with the overall region died on January 6, 1980, in Nevada City. His remains were taken to Colfax for burial because this is where his family was. The inscription "Will live on in our hearts forever," is etched into his humble wooden plank grave monument. (CW.)

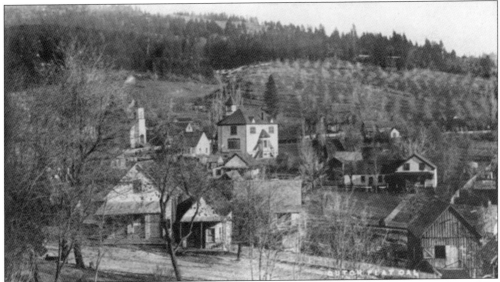

The cemeteries of Dutch Flat conjure a sense of awe when faced with the shear enormity of the over-13-acre site amongst the towering Sierra conifer and entangled old growth periwinkle. Dutch Flat, "Athens of the Foothills," also known as Dutchman's Flat, Dutch Charlie's Flat, and Charley's Flat, is now a small unincorporated community in Placer County, about 30 miles northeast of Auburn. Founded by German immigrants Joseph and Charles Dornback in 1851, from 1854 to 1882 it became one of the richest gold mining locations in California. There are at least three cemeteries in Dutch Flat: Pioneer, established in 1851; Fraternal Order, established around 1855 (Masons, Odd Fellows, Woodsmen); and Chinese, established in the 1860s. (CAHSA.)

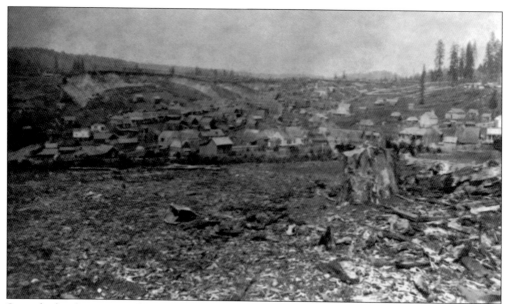

Steep hydraulic cuts would eventually extend to within feet of residences and the cemeteries, as seen in the distance of this Lawrence & Houseworth westerly view from about 1866. Mining operations at Dutch Flat reached their peak during the 1870s, with thousands of miners working the surrounding hills. In the distance at upper right is the western edge of the pioneer cemetery of Dutch Flat. By 1872, consolidated mining companies holding dozens of individual claims ushered in an era of aggressive industrial-grade hydraulic mining. Extremely high water pressure was used to blast the auriferous cliffs, freeing ounces of gold from tons of cemented gravels. (LOC.)

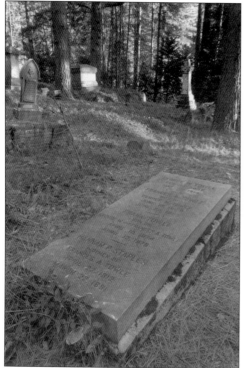

The Dutch Flat Fraternal Cemetery, established in 1855, is situated on a deceptively large west-facing slope amongst giant conifers and 100-year-old periwinkle. Seen here is a modern view of the Towle brothers' gravesite in Dutch Flat Fraternal Cemetery, with George in the foreground, Edwin at center, and Allen in the back. According to Towle Brothers company records, from 1861 to 1907, the Towle Brothers Lumber Company was among the largest in the state, owning over 20,000 acres of land and a narrow-gauge railroad well over 38 miles long and employing around 200 men, including at least 50 Chinese laborers. (CW.)

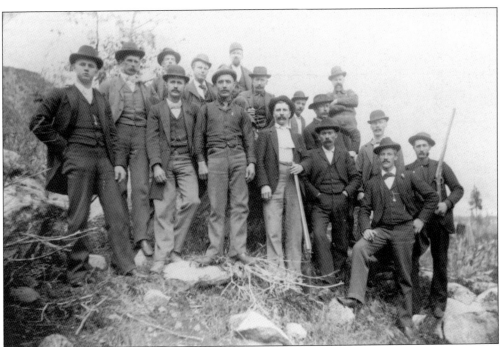

The Towle brothers and crew are pictured around 1880. All three of the Towle brothers, Allen, Edwin, and George Washington (front center), including their immediate families, are interred in the Dutch Flat Fraternal Cemetery. The brothers were closely associated with the Odd Fellows in Towle (now extinct) and Dutch Flat. (CRM.)

The terraced gardens of the Parsee Cemetery in Hong Kong, one of the two primary cemeteries used by Chinese immigrants in California when shipping burial remains home, are pictured around 1902. In 1853, Dutch Flat had a population of 6,000, including 3,500 Chinese. Adjoining the Dutch Flat Pioneer Cemetery and below the fraternal cemetery is the Chinese burial ground, almost lost within the forest. A Chinatown evolved in Dutch Flat early in the 1850s, and by the late 1860s, when the transcontinental railroad construction was underway nearby, Dutch Flat became home to the largest Chinese settlements outside of San Francisco. (LOC.)

This sizeable gathering of the drinking men of town occurred in 1899 or 1900. Among those pictured are Charles "Carl" G. Schwab (with the two kids on left), his brother Theodore Ludwig Schwab (kneeling at right), Andrew Deeds (sitting on bottle, center), Rob Cross, William Oliver "Bill" Moulton (with guitar), three Booth boys (Garret W., William H., and David H.), and a dog. (CAHSA, Keck Collection.)

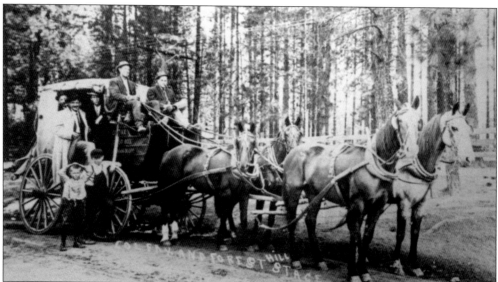

Iowa Hill (elevation around 2,860 feet) sits astride what is known as the Iowa Hill Divide, a long ridge line ascending above 4,000 feet. The historic Gold Rush town, California Historic Landmark No. 401, is a true boomtown linked to massive gold discoveries in the early 1850s, along the famous Blue Lead. Iowa Hill was founded around 1853 by the Kennedy brothers, said to have been from Iowa according to Walsh's *Hallowed Were the Gold Rush Trails*. By 1855, it was the most populated locale in Placer County. Many of the towns and mining camps along the Iowa Hill Divide were once on popular stage routes, as evidenced by this 1880s photograph. (CAHSA.)

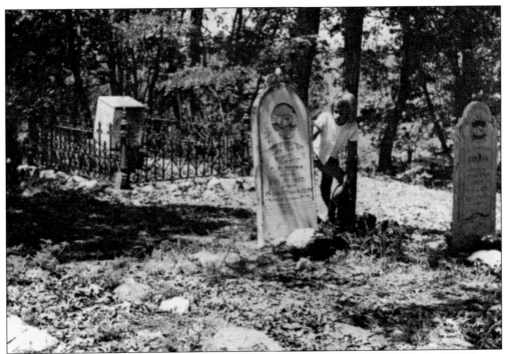

A 1962 view of the Iowa Hill cemetery is seen here. According to Thompson & West's 1882 *History of Placer County*, the county surveyor of 1856 said, "We have over 400 miles of ditches and canals alone in the vicinity, selling at $1.00 an inch." With news of weekly gold earnings of over $100,000, the population grew dramatically, swelling to an astonishing 10,000 by 1860, and by 1880, total gold production was estimated at $20 million. Today, about 200 people live in or around the off-grid hamlet of just one main street once known as Iowa City. (Sunset Publishing Corp.)

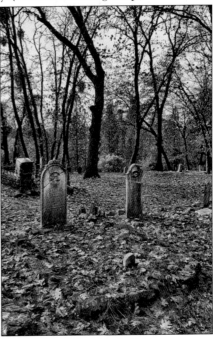

This is a 2015 view of the Iowa Hill Cemetery near the graves of Olive Brown and Nathan Dixon, to contrast with the previous image. Change comes slowly to the Iowa Hill Cemetery, but without continued restorative efforts and periodic maintenance, the 160-plus-year-old cemetery would be far less of an informative historical treasure. Inspired interpretation and community involvement atop Banjo Hill have helped create a meaningful model to follow. (CW.)

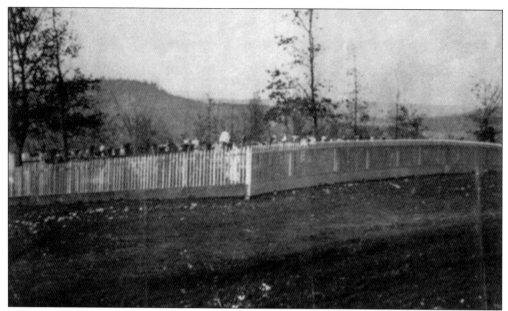

The Protestant-Masonic-Odd Fellow and town cemetery in Iowa Hill dates to the early 1850s (as early as 1851) and once contained many more monuments than today. The remoteness of the site has left it vulnerable to vandalism, and the often-extreme weather of the Sierra has contributed greatly to the loss and deterioration of many of the surviving monuments. (IHCC.)

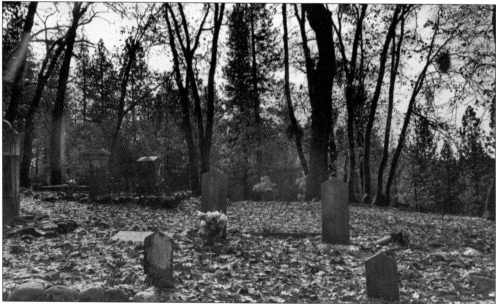

Shown here is the Macy family plot in 2015. Interestingly, while the cemetery here today is known as the Old Iowa Hill Cemetery, Iowa Hill Divide Cemetery, or just Banjo Hill, this is actually not the original town cemetery. The earliest known cemetery was once situated near what is considered downtown Iowa Hill. The oldest Iowa Hill cemetery known (1851–1853) was in the yard of the Schwab home, where there was evidence of several graves bordered with small rocks. At one time, there was a white marble headstone that read, "To the memory of Joseph Dunagan, who died at Iowa Hill, July 30, 1855, aged 24 years, formerly of Walker County, GA." (CW.)

This is a photograph of Carl Schwab from about 1900. As the tale unfolds, when Stuart Schwab (1899–1966) built the house, he took a bulldozer and allegedly pushed all of the remaining stones into the nearby canyon and buried them. Mining claimed the remaining hillside in the immediate vicinity. Very few, if any, of the remains or monuments made a recorded transition to the current location. (IHCC.)

Herbert C. "Big Herb" Macy Sr. remembers, "There were graves where the Schwab's home was built. When we were kids we would go down there and play. There were 10 gravestones that I could remember. Some were good stones and some were wood rotting away and I remember the big white stone as big as a square table." Pictured here is the Charles and Elizabeth section of the Macy family plot. A humble wooden monument with an embossed capital "M" alongside a ground-level granite slab inscribed with the names and dates of the interred rest gently amongst the heritage oaks and cool silence. (CW.)

The ornate and lonely grave of 31-year-old junior partner in Papa Brother's Livery, saloon keeper, and hostler G. Julius Papa (1858–1890), originally from Switzerland, is seen here. Papa was a pioneer resident of Iowa Hill and younger brother of Giovanni Battista "John" Papa. A dedicated and lifelong member of the Order of Odd Fellows, Julius died alone in San Francisco of an acute blood disease, and it was very likely the Odd Fellows who arranged transport of his remains back to Iowa Hill and his family. (CW.)

Pictured here around 1890 is Giovanni "John" Battista Papa (1828–1926) of Iowa Hill and life member of the IOOF and 76-year resident and pioneer miner of California. He was born in September 1826 in Pontirone, Ticino, Switzerland, and would live to be nearly 100 before surrendering to myocarditis in September 1926. (CAHSA.)

John Papa is buried in the Old Iowa Hill Cemetery next to his youngest son, Frank Papa, also of the IOOF. Frank died early due to a disastrous mining accident in nearby El Dorado County. Iowa Hill was once home to Placer Odd Fellows Lodge No. 38, instituted on April 14, 1855, and eventually consolidated with Colfax Lodge No. 132 on November 26, 1906. (CW.)

South of the one-lane road from the Old Iowa Hill Cemetery stands the Catholic cemetery of Iowa Hill. St. Dominic's Cemetery is one of three recognized remaining cemeteries in Iowa Hill. The others are the nearby Old Iowa Hill and Chinese Cemeteries. All are situated atop Banjo Hill, northeast of town, and all are protected, maintained, and superbly historically interpreted by the Iowa Hill Community Cemetery Inc. and members of the Balmain, McClure, and Yonash families. (CW.)

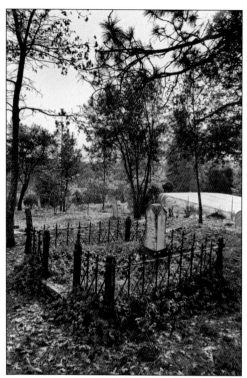

Pictured here is the beautiful grave of Olive Gleeson (1868–1889), beloved wife of M.R. Gleeson. Her touching gravestone reads, "Beneath deaths olive tree of peace our Olive lies at rest. Or'e mourning hearts let weeping cease, for she, we loved is blest. Ay! Blest and safe within those gates where grief and pain come never. There our lost Olive branch awaits our coming home forever." (CW.)

Pictured here around 1865 is St. Dominic's Church and Cemetery, originally christened St. Joseph's. The cemetery was once the location of the first and only Catholic church in Iowa Hill. The earliest recorded burials date to 1859, with at least one of the McGowan infants buried in that year. The church was never rebuilt after a catastrophic fire in the summer of 1920; eventually, even the few remaining boards were hauled off for building material elsewhere in town. (IHCC.)

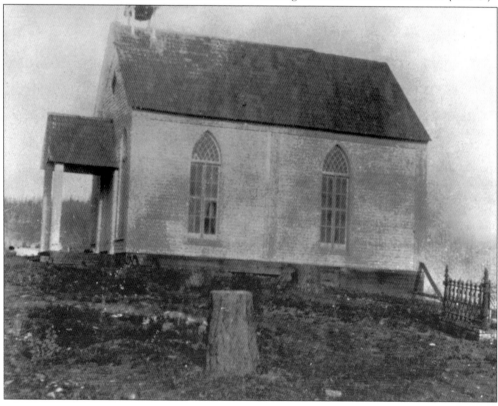

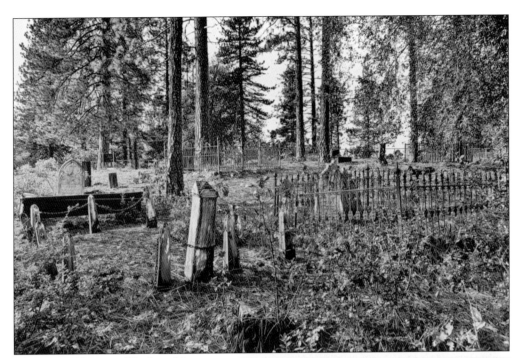

This is a 2015 view of St. Joseph's Cemetery. The first Catholic priest to visit the area was probably Father Shanahan, pastor of Nevada City. In 1852, he took the trail leading through Grass Valley to Illinoistown and Iowa Hill. In 1854, Fr. Peter Deyaert was appointed to care for the northern mines, and his records show that he visited and had baptisms in Iowa Town in November 1854. (CW.)

Here amongst the twisted oaks is the exquisite artistic ironwork that protects the grave of Joseph Papa, co-owner of Papa Brother's Livery and potentially Exchange Livery in Iowa Hill. His brothers and extended family are buried nearby in the Old Iowa Hill Cemetery. The church was never rebuilt after being partially destroyed by the fire that swept through the town on September 29, 1920. The church blew down a final time, and the boards were incorporated into Iowa Hill homes. The bell from St. Joseph's Church was stored at the Colfax St. Dominic's for safekeeping and is now mounted in front of the church there. (CW.)

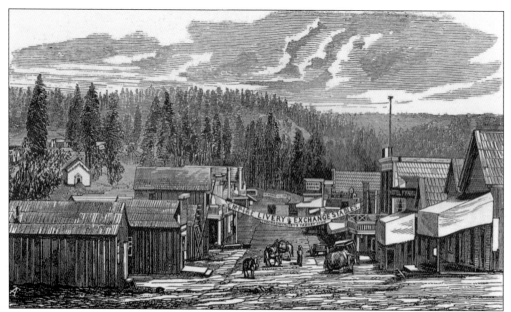

Iowa Hill is pictured here in *Hutchings' California Magazine* around 1860. Even today, the hydraulic escarpment comes to within inches of the roadside. Town cemeteries were not spared destruction; many in nearby Bird Flat were washed away completely or had to be hastily relocated. Eventually, over-mining and numerous conflagrations reduced the population of "the town that refused to die" to a shadow of what it once was. (CW.)

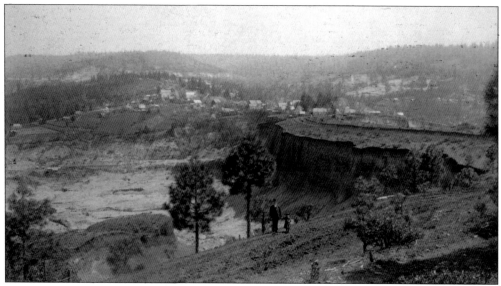

Iowa Hill is seen here around 1870, looking northeast back toward town. The cemetery is located in the hills above town. Often, hydraulic mining would approach the very edges of the community. As seen in this photograph, Iowa Hill Road looks more like the nearby Steven Trail (established by Truman Allen Stevens in 1859); hydraulic and drift mining very nearly undermined and took out the road into town. (CAHSA.)

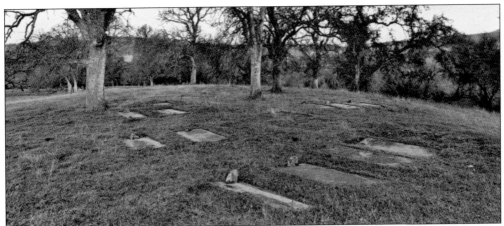

This is one of the truly lonely cemeteries of the Sierra Nevada, situated on the side of the old Spenceville-Marysville Road atop an oak-covered knoll along the toe of the foothills. This cemetery alongside Dry Creek is without a quaint picket fence, a fortuitously donated elaborate wrought metal sign or gate, graceful arch, trace of marble monument, or even a single tearful cherub or engraved hand to offer guidance to a departed loved one. There is little at all to indicate that a cemetery is there. Nonetheless, the setting is soothing, fitting for these pioneers of Yuba and early Nevada County. A tight grouping of some 17 graves lies almost hidden in the tall grass under majestic blue oaks overlooking the creek. (CW.)

The cemetery came into being as a result of a cholera epidemic that struck a wagon train camped on one of the ridges near Cabbage Patch around 1860. The 17 graves are covered over by concrete slabs approximately three by six feet, in an overall burial plot of about 50 by 100 feet. Most of the graves have only a piece of fieldstone set into the concrete at the western edge of each. Only three grave slabs are marked with names, the family of Abraham Hambleton, Ellen Hambleton, and Ben Hambleton. Ellen and Abraham migrated overland from Arkansas in the early 1850s, and by 1854 had built a hotel and blacksmith shop in Cabbage Patch. (GLO, 1880.)

The names of the Hambleton family members are now scarcely legible and stamped into the concrete slab markers. During the early 1940s and 1950s, Camp Beale (later Beale Air Force Base) owned the land and cleared many of the surviving buildings or used them as part of training maneuvers. At this time, as reported by local newspapers, the historic cemeteries and lone graves in the vicinity (Kneebone, Foster, Waldo, and others) were bulldozed in order to prepare the land for artillery training. (CW.)

Shown here is the home and ranch of respected Odd Fellow W.T. Foster of Cabbage Patch, as depicted in Thompson & West's 1879 *History of Yuba County*. In a pasture not far from the Cabbage Patch cemetery, adjacent to the ruins of an old homestead, is a lone and toppled quarried granite block. Near the base of this obvious grave monument, on the polished surface of one of the four faces is the barely legible letter "W" alongside three engraved chain links—a symbol strongly associated with the IOOF. The lost grave site of W.T. Foster? (Yuba County Library, California Room, Public History Archive.)

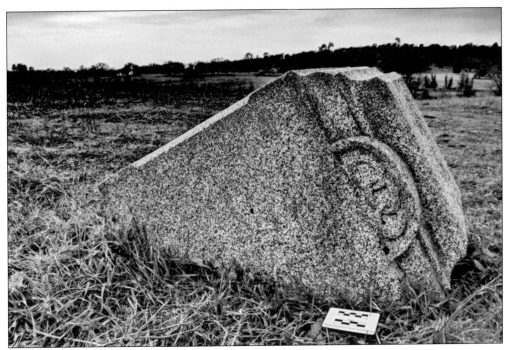

At one time, the town of Cabbage Patch–Waldo boasted a hotel, blacksmith, saloon, stage stop, and school. The US military seized the land around Cabbage Patch and created a training center and grounds, renaming the area Spenceburg during World War II. All cemeteries were bulldozed and graves given cement slab blankets in an effort to protect them. (CW.)

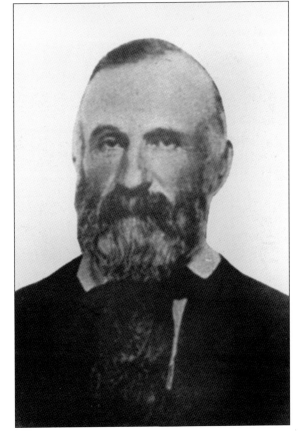

This is an 1870s portrait of the town's namesake, William Waldo, frontiersman turned politician. All that remains of the town are a few foundation remnants and the cemetery, as is the case at many sites throughout the Gold Rush region. The Cabbage Patch–Waldo Cemetery is situated within the Spenceville Wildlife and Recreation Reserve. (SCP.)

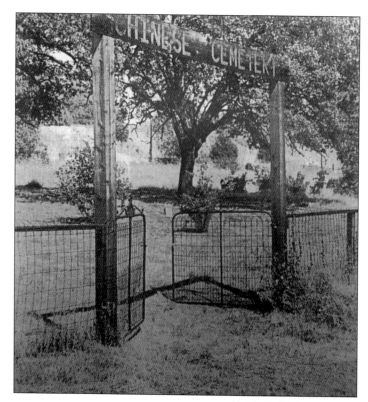

This is a 1950 view of Auburn's Chinese Cemetery entrance and gate. The mining opportunities that followed the Chana, Woods, and Stevens party gold discoveries in the spring of 1848 and railroad construction of the 1860s helped make the town of Auburn, in what is now Placer County and initially known as the North Fork Dry Diggings, home to thousands of Chinese laborers in the early 19th century. (The *Auburn Journal*.)

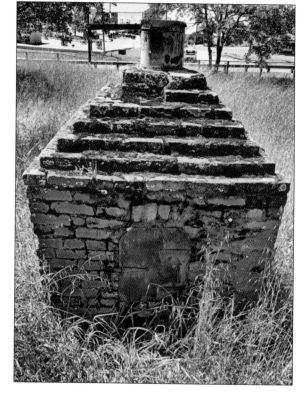

The Auburn-area Chinese Cemetery, established around 1860, is situated atop Golden Mountain, as it was known to local Chinese. The 2.5-acre site that was well over a mile outside town in the late 1850–1870s sits now adjacent to State Highway 49. The burial ground still contains multiple burials according to local historians. All other remains were removed after a period of time and either returned to China for reburial or moved to an alternate local cemetery. (CW.)

The cemetery was rededicated in 1988 by the Native Sons of the Golden West and recognized as a significant cultural site, a crucially important historic resource and vital link to the rich Chinese American heritage of California. The last recorded ceremony and burial in the cemetery was in March 1941, with the funeral of Wong Bong, a 78-year-old gardener and native of China. The cemetery has been described in a local newspaper as "a semi-lost piece of ground," but efforts persist to help preserve and protect this rare resource. Numerous charitable organizations, public and private, together with concerned and devoted community members, have helped maintain the cemetery and bring about awareness of the historical role a cemetery such as this plays in the history of the state and country. (CW.)

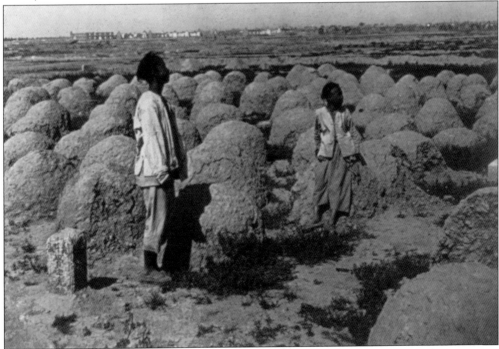

Shown here is a rural Chinese cemetery near Tien-Tsin, China, around 1900, one of two primary cemeteries used by Chinese immigrants of the California Gold Rush when shipping the remains of loved ones back to China for burial. Note the similarities in the grave monuments between Auburn and Tien-Tsin. (LOC.)

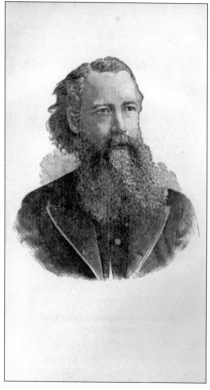

In the entirety of Placer County's Sierra slopes, a candidate for the loneliest cemetery must be the final resting place of the fated members of the Esoteric Fraternity and Society. The cemetery, located in Applegate, is on private property (entrance seen here); photographs are discouraged and it is not open to the public. Access to this property is by appointment only. Only fraternal members are interred within. The burial ground sits alone amongst the Ponderosa pines and massive gnarled manzanita in a once-vast 160-acre homestead appropriated by Hiram Butler. (CW.)

Hiram Erastus Butler (1841–1916), the metaphysical scholar and founder of the Esoteric Fraternity, is seen in this 1899 portrait. The Esoteric Fraternity was founded around 1886, and in 1889, the "bearded mystic," as newspapers were known to call Butler, took 12 followers from Boston to Applegate and settled on a large homestead overlooking the American River. By 1891, the group had built an 18-room lodge and hall, established a farm, and set up the Esoteric Publishing Company printing press to publish Butler's revelatory books. The clay for the brick and the lumber for the lodge was harvested from the fraternity property and fired and hewn on the spot. (CW.)

This is a mystical diagram from Hiram Butler's *Seven Creative Principles*. Today's newspaper horoscopes are modeled largely on Butler's 1887 formulas. By 1899, the society had garnered an additional nine members and had improved upon some 60 acres, including numerous buildings and a cemetery for the members. Together with fellow metaphysical writer Enoch Penn, Hiram Butler would author and publish some 17 books with the Esoteric Publishing Company and was a much sought after speaker in his time. He died in November 1916 and is buried outside his library window in Applegate. (CW.)

DIAGRAM OF CHART REFERRED TO IN THIS LECTURE.

This is a 1973 newspaper advertisement placed by the fraternity as a public plea to help find the murderer of a member. The membership had dwindled to only a few by 1970, and dark times were to befall the Esoteric Order. As of 2015, the mysterious murder of fraternity member Mathew Bosek, one of two remaining members, is still an unsolved case. Bosek came to the Esoteric Fraternity in 1922, an escapee of the Bolshevik Revolution. He was a gardener and trusted printer of some of the earliest Hiram Butler Esoteric Publishing Company works. (CAHSA)

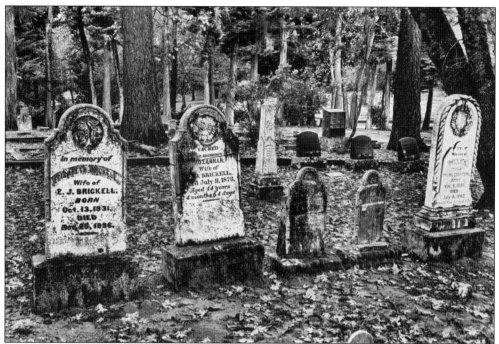

The Brickell family gravestones represent the oldest surviving stone monuments in the Colfax Cemetery, some dating as far back as 1854. The year was no later than 1854 when the first person, Dan Bayless, was buried in what was a small parcel of land conveyed to the town by John Burns in May 1878. In February 1913, a map showed an Evergreen Cemetery located on the property of J.F. Seims of Illinoistown. (CW.)

This 1906 photograph shows an easterly view of Colfax. The town cemetery can be seen in the center distance on the hills outside town, amongst the Seims family land and orchard. The Seims family eventually deeded portions of their land to Placer County for use as a cemetery. On May 9, 1917, the Placer County board of supervisors established the Colfax District Cemetery. The site is cared for by the Colfax District Cemetery Committee. (CAHSA.)

This is the grave of Maria Kennett (1853–1918) as it looked in early 2015. According to the Colfax Area Historical Society, Kennett, having taken the English name of Maria and that of her eventual husband William Kennett, was a Native American woman living in Colfax in the early 1900s. As the story goes, she "saved the life of a white miner who was pinned under a rock in the American River." She nursed him back to health and they later married. Maria is buried alongside her husband. With the aid of a friend, her belongings, at the time of her death, were burned, given away, or buried with her, recognizing her native funerary custom of *potlatch*. The ceremony is briefly mentioned in her obituary, which was recorded in the *Colfax Record* newspaper. (CW.)

Here is an early 2015 east-facing view of the grave and family plot of James Hayford (1840–1932). A native of Maine, a young Hayford arrived in Placer County with his father and brothers in the late 1850s via an overland route. A veteran of the Civil War (he joined a regiment here in California), he was a member of the Illinoistown Masonic Lodge No. 51 of Colfax. He served as supervisor for the Colfax District and as undersheriff for Sheriff John Butler of Colfax. His family lived on the Hayford Ranch, near the small farming community Magra, noted for its fruit. (CW.)

The background of this photograph shows the immense stone monument of the extended Farish family plot during a funeral in the mid-1970s. Featured in the foreground are the graves of the Boyer family (John, Eliza, and daughter Lizzie). The John Boyer family was a prominent mining-turned-ranching family from the area. The Farish Monument is so named for the family of California pioneer Adam Farish. Beneath the multi-ton river boulder, pulled into place by a team of five strong horses, rests a three-chamber sealed vault, said to be of "everlasting endurability." (Kershaw Collection.)

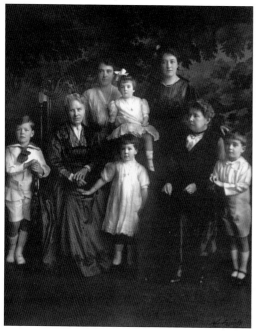

Three generations of the Farish-Paddock family are pictured here in 1916. The cemetery was first established in 1855 with the burial of three men shot by Jim Webber, a somewhat notorious highwayman. Timbuctoo was officially established in that same year, though mining was underway in the vicinity years earlier. Years later, Farish family descendants purchased the cemetery land from the Bushby family (interred in the nearby Smartsville Fraternal Cemetery) for $100 plus a $16.50 "investigating and recording fee." (Kershaw Collection.)

Descendants and friends met annually to maintain the Timbuctoo cemetery, seen in this view of the Sims, Collbran, and Farish families enjoying a picnic break around the 1980s. Revered mining engineer John Bolton Farish, son of California pioneer Adam Farish (a captain with the Kit Carson Caravan in 1849) instructed his descendants to "bury them all in some remote region, far from the maddening crowds, where a man and his own might rest undisturbed, safe from profane hands for eternity." In 1929, upon the death of J. Farish, descendants arranged the respective disinterments of the family, and together with Rev. H.H. Miller from Gridley, laid the generations to rest at the Timbuctoo cemetery. Since then, numerous family members and close family friends have been buried in this privately owned historic cemetery. (Kershaw Collection.)

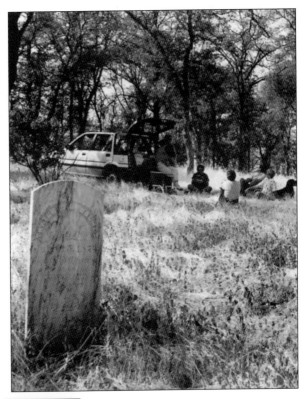

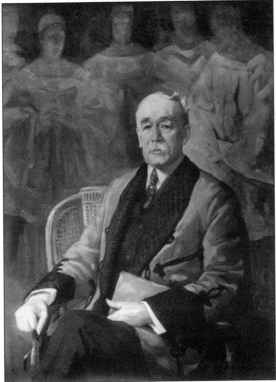

This is a portrait of John Bolton Farish from about 1900. The Farish Monument is so named for California pioneer Adam Farish. Adam Thomas Farish left St. Joseph, Missouri, in March 1849 and arrived six months later. After trying his hand at mining, Farish set up a store in a tent at Bigler's Bar near Oroville. In 1850, he moved to Marysville and opened a store. While in Yuerba Buena (San Francisco) in 1850, Farish met a Chilean ship captain. The captain, under a previous arrangement, had brought him a special grass seed from Chile. That seed, Farish was convinced, would be of use in California. The seeds were *Medicago sativa* L., otherwise known as alfalfa. Adam T. Farish is attributed with the introduction of alfalfa to California and the western United States. (Kershaw Collection.)

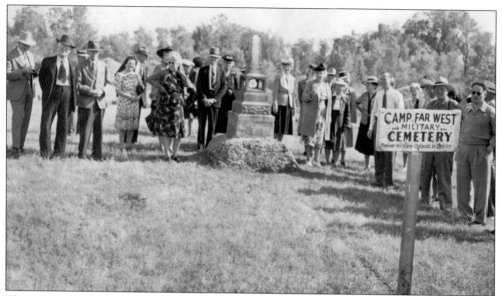

The Camp Far West Cemetery (CFWC) is pictured here in 1950, during the rededication ceremony by the Native Sons and Daughters of the Golden West. The CFWC, a US historical landmark, commemorates the earliest Army outpost in Superior California. It was conceived as a means to mitigate anticipated Native American uprisings as a result of the land rush created by the discovery of gold. The cemetery, near Johnson's Rancho, was established in 1844 and used by both military and would-be settlers traveling the Emigrant Trail. It is occupied by at least 30 nameless graves. All the graves are without headstones and most lost to memory. A memorial plaque once adorned the 1910s metal obelisk monument at the center of the cemetery. It read, "In honor of the known Military buried here: Pvt. George Eckweller, Co. F, 2nd Inf. 1849, Pvt. John Stevenson, Co. F, 2nd Inf. 1849, Pvt. Newton Barnes, Co. F, 2nd Inf. 1849, Pvt. Baldwin Co. E, 2nd Inf. 1850." (Both, YCL, California Room, Public History Archives.)

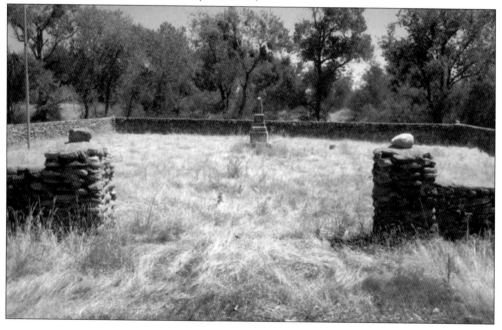

A fallen member of the Woodmen of the World, as part of the brotherhood, was offered a grave monument guaranteed to be one-of-a-kind. As seen in this 2015 photograph of the grave of Woodman J.F. Trevethick (1873–1901) in Keystone Ranch Cemetery, the sculpted concrete monuments, generally referred to as stone trees, take on the appearance of a throne in the forest. The entire throne, which could indicate the grave of a sovereign, is complete with embroidered cushions and adornments, draped in a funeral shroud, and intended to look rooted to the ground. (CW.)

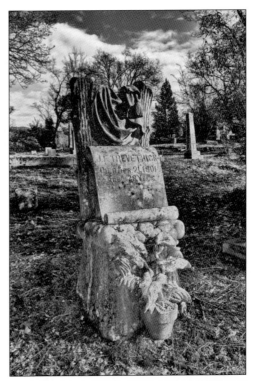

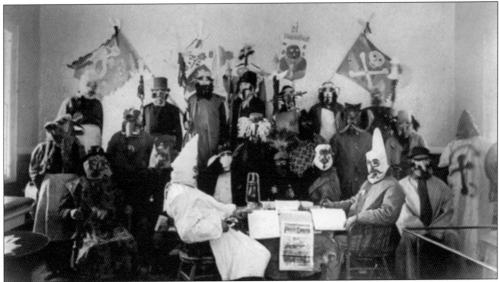

The WOW organization was founded in 1890 by Joseph Root. Root was a member of several fraternal organizations, and after hearing a religious sermon about pioneer woodsmen clearing away the forest to provide for their families, he was inspired to start a society that "would clear away problems of financial security for its members." The Woodmen took their ritual and secrecy seriously, as seen in this 1860s photograph of a gathering. During ritual, members donned the costumes and likenesses of forest creatures and supernatural beings reported by lone woodsmen. Members were initiated and given an annual password, and the constitution provided for an escort, watchmen, and sentry during burial. (SHRL.)

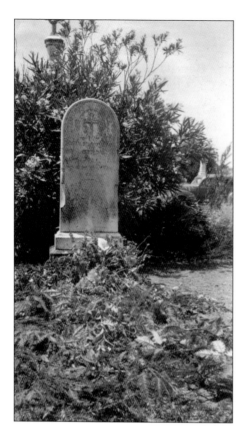

The grave of Meriam Marjory "Mary" Murphy Covillaud (1831–1867) in historic St. Joseph's Catholic Cemetery (established 1856) is pictured here around 1930. Notice the offerings of palm fronds. Mary was rescued by the first Donner relief party in 1847. (YCL, California Room, Public History Archives.)

Pictured here around 1855 are Mary Murphy Covillaud and two of her children, Mary Ellen and Charles Jr. On Christmas Day 1848, she married Charles Julian Covillaud, a Frenchmen 15 years her senior. (YCL, California Room, Public History Archives.)

This photograph, taken about 1960, is a general overview of the Marysville City Cemetery. In the foreground is the paupers' section of the burial ground, freshly mowed. Notice the grid pattern emerging from the open paupers' field, indicating the hundreds of burial locations in this section. The historic Marysville City Cemetery, established in 1850, is home to an estimated 10,000 burials. Also within the grounds are an infant section, an African section, sections dedicated to fraternal orders, a veterans' section, a nondenominational section, and separate but adjoining Chinese, Japanese, and Jewish cemeteries. Known as the Gateway to the Goldfields, Marysville became the primary conduit of commerce and supply for the northern mines and enjoyed a prolonged period of prosperity. Nearly every nationality and all social and economic classes are represented in this incredible California Historic Landmark cemetery. (MCC.)

The Marysville City Cemetery is pictured here during the catastrophic 1937 flood that inundated not only the cemetery but the entire region. After 1848, Marysville became the temporary state capitol, so important, it was considered one of California's three primary cities, along with San Francisco and Los Angeles. The burial ground is known as the first city-owned cemetery west of the Rockies, and many of the city's early notable citizens are interred here. With some exceptions, the last burials here took place in the late 1920s. (YCL, California Room, Public History Archives.)

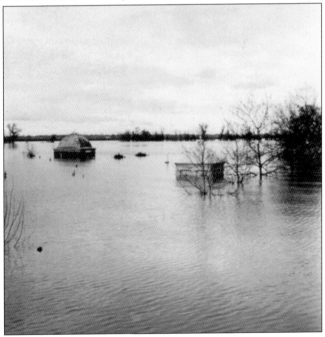

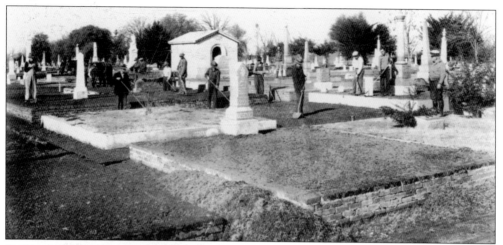

Under prison guard around 1919, jail inmates maintain Marysville City Cemetery, once a much more common occurrence than it is today. In May 1994, the State Historical Resource Commission officially declared the cemetery for the city of Marysville a California Point of Historical Interest (FPYCH.)

Pictured here is the grave of Harriet Frances Nye (1828–1870), sister of Mary Murphy (Covillaud) and a Donner Party survivor. Harriet first married William M. Pike in December 1842 at the age of 14. The Pikes had two daughters, Naomi and Catherine. While on the overland journey to California from Missouri, her husband was killed in a shooting and infant daughter Catherine succumbed to starvation. After her rescue, Harriet met and married Michael C. Nye in June 1847 at Sutter's Fort. After living in Marysville for several years, they moved together to Oregon, where Harriet died at the age of 46. Her body was returned to Marysville for burial near her family. (YCL, California Room, Public History Archives.)

This portrait of Frenchman Charles Covillaud, known as the founder of Marysville, is from about 1855. In the fall of 1842, Johann Augustus Sutter leased the land that would become the city of Marysville to Theodore Cordua. Cordua raised livestock on the land and in 1843 built a home and trading post at what is now the southern end of D Street. In 1844, Cordua obtained an additional seven leagues of land from the Mexican government (Honcut Rancho). Covillaud, a former employee of Cordua, struck it rich in the gold fields and returned to buy one half of the Cordua Ranch in 1848 with the help of the family of his new wife, Meriam "Mary" Murphy. The other half was purchased by Michael C. Nye and William Foster in January 1849. (YCL, California Room, Public History Archives.)

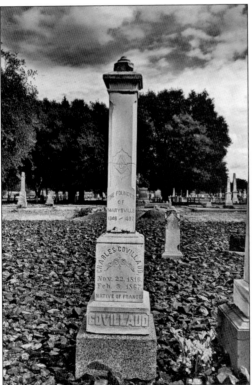

The grave of Charles Covillaud is pictured here around 1930, in the Marysville City Cemetery. In October 1849, Covillaud sold three-fourths of his ranch to Jose Ramirez, John Sampson, and Theodore Sicard. During the Gold Rush, the ranch became a primary debarkation point for riverboats from San Francisco and Sacramento filled with miners on their way to the northern mining sites. Due to this massive inflow of humanity, in 1850, the four partners (Covillaud, Ramirez, Sampson, and Sicard) hired French surveyor Augustus Le Plongeon to create a master plan for a town. Marysville was incorporated by the new California legislature, and the first mayor was elected in 1851. Marysville prospered during the Gold Rush era, becoming one of the largest cities in California. In 1857 alone, over $10 million in gold was shipped from Marysville's banks to the US Mint in San Francisco. (YCL, California Room, Public History Archives.)

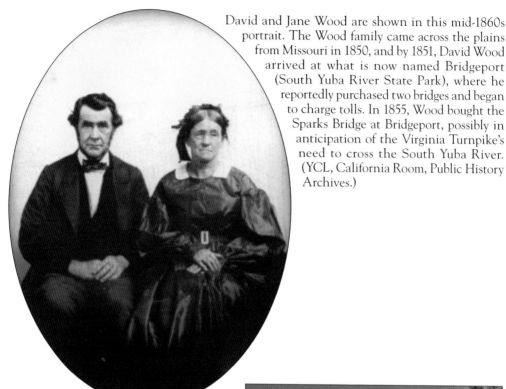

David and Jane Wood are shown in this mid-1860s portrait. The Wood family came across the plains from Missouri in 1850, and by 1851, David Wood arrived at what is now named Bridgeport (South Yuba River State Park), where he reportedly purchased two bridges and began to charge tolls. In 1855, Wood bought the Sparks Bridge at Bridgeport, possibly in anticipation of the Virginia Turnpike's need to cross the South Yuba River. (YCL, California Room, Public History Archives.)

Here is the grave of David and Jane Wood, as seen in the Wheatland Cemetery in early 2015. In 1856, David Wood and others formed the Virginia Turnpike Company to serve miners traveling to California's northern gold mines and Nevada's silver mines following discovery of the Comstock Lode in 1859. In 1860, Wood also had a store in Virginia City and one in Sierra Valley, and owned a sawmill at Plum Valley near Forest City. By the 1870s, he was living comfortably on his ranch in Wheatland, and it was there he died in 1875. (CW.)

In this 1930s view of Yuba City and town cemetery, the burial ground (established in 1853) is at center. Yuba City (also called Yubaville) became an important agricultural center during the years following the Gold Rush and is now the seat of Sutter County. The numerous pioneer families interred here share close connections with the Sierras and the overall region's history. (CMMSC.)

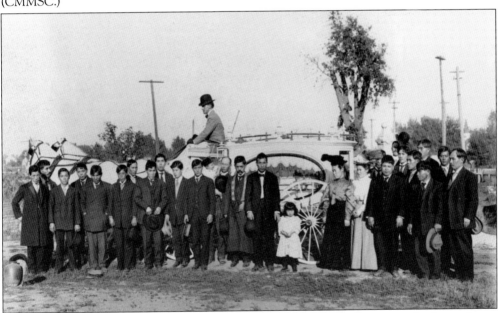

Pictured here around 1880 is a Chinese funeral procession in Yuba County, with a horse-drawn hearse. By 1860, thousands of Chinese nationals were arriving in California, and by the mid-1870s, differences in funeral custom and a gathering prejudice acted to prohibit Chinese people from burial in public grounds. This prejudice was solidified by the Chinese Exclusion Act. Signed by Pres. Chester Arthur in May 1882, the Chinese Exclusion Act regrettably became the first law implemented to prevent a specific ethnic group from immigrating to the United States. It was repealed by the Magnuson Act in December 1943. (CMMSC.)

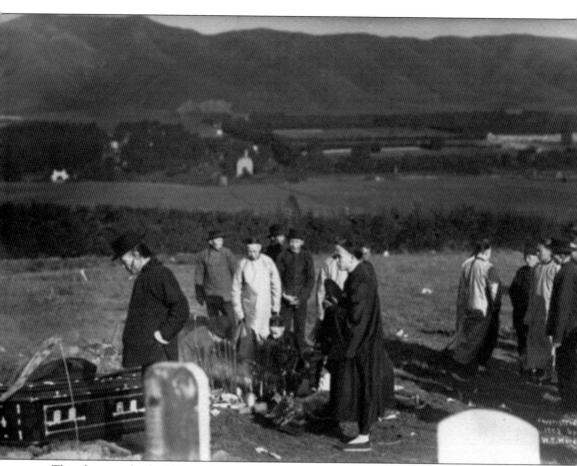

This photograph of a Chinese funeral in Colma is a rare glimpse at a seldom-documented event. Before 1900, Chinese funeral custom often required the remains be disinterred after a period of time to be prepared for shipment back to China for reburial with family—a practice shunned by many Caucasian neighbors. The funeral ceremony in this 1903 photograph illustrates the melding of Western and Eastern burial traditions. (CHS PIC 1986.03-AX, W.E. Worden Collection.)

The gravesite of Yuba County and California pioneer Pierre Theodore Sicard is located in the Wheatland Community Cemetery. Frenchman P.T. Sicard was a sailor who from 1842 to 1843 worked for John Sutter as the manager of Hock Farm. Sicard became a notable player in the early development of Yuba County, when Covillaud (founder of Marysville) sold the remaining half of his property to him in the mid-1840s. Sicard Flat, near the intersection of California State Highway 20 on the Yuba River, is named for him. In addition to Cordua's Honcut Rancho, the four partners, Covillaud, Ramirez, Sampson, and Sicard, known as Covillaud & Co., also bought Cordua's leased land on Rancho New Helvetia from Sutter. In 1873, Sicard died in Wheatland. (YCL, California Room, Public History Archives.)

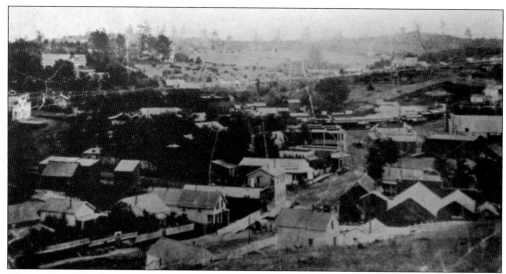

This is the oldest known photograph of Auburn, also known as North Fork Dry Diggins, from about 1860. In the spring of 1848, a group of French gold miners arrived and camped in what would later be known as the Auburn Ravine. This group was on its way to the gold fields in Coloma and included Francois Gendron, Philibert Courteau, and Claude Chana. (CAHSA.)

The grave memorial of Claude Chana in the Wheatland Community Cemetery is pictured here in 1949. During that same year, the previously unmarked grave of Chana was rediscovered and memorialized by the Native Daughters of the Golden West, Parlor No. 218. Chana became the first to discover gold in the Auburn area in May 1848. The area soon developed into a mining camp; it was officially named Auburn in August 1849. By 1850, the town's population had grown to about 1,500 people, and in 1851, Auburn was chosen as the seat of Placer County. In 1865, the Central Pacific Railroad, the western leg of the First Transcontinental Railroad, reached Auburn. (YCL, California Room, Public History Archives.)

At this 1890s home funeral in Sierra County, a splendidly adorned casket with elaborate floral arrangements is the center of attention. The deceased may remain lying in repose for days, allowing family and friends to make arrangements and receive visitors. The etiquette of a Victorian-era funeral meant a person must wait to receive their formal invitation. However, it was improper to send invitations to a funeral of one who died from a contagious disease. In this case, there would be a notice of death posted for public view. While en route to the burial, there were exactly six pallbearers, who walked in threes on each side of the hearse or in a carriage immediately before, while the near relatives directly followed the hearse succeeded by those more distantly connected. Strict social etiquette typically denied women the privilege of following the remains to the grave. (SHRL.)

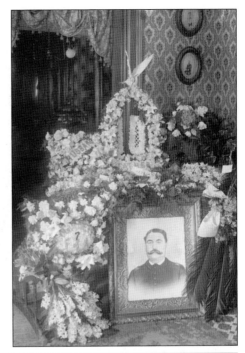

This Native American cemetery located in Placer County exemplifies the contemporary setting shared by many of the indigenous burial grounds of the region, that being a complex blend of traditional and historical expressions of funerary custom. In Marysville City Cemetery, the gravestone of C.S. Shepherd, who died in 1854, reads: "California hath her Treasure, Whose value is Untold? But her soil holds treasures, dearer more priceless far then gold. For many noble spirits in her bosom are at rest. And the gold sands of her valleys, Shroud many a manly breast." (CW.)

DISCOVER THOUSANDS OF LOCAL HISTORY BOOKS
FEATURING MILLIONS OF VINTAGE IMAGES

Arcadia Publishing, the leading local history publisher in the United States, is committed to making history accessible and meaningful through publishing books that celebrate and preserve the heritage of America's people and places.

Find more books like this at
www.arcadiapublishing.com

Search for your hometown history, your old stomping grounds, and even your favorite sports team.